The Art of
PHOTOGRAPHING
Water

Cub Kahn

D1278622

Rivers, Lakes, Waterfalls, Streams and Seashores

AMHERST MEDIA, INC. ■ BUFFALO, NY

This book is dedicated
to Jill,
for the magical, unforgettable times
we've shared in the wilderness;

and

to Dad,
for your love through all the years.

Copyright © 2002 by Cub Kahn

All photographs by the author.

All rights reserved.

Published by:
Amherst Media, Inc.
P.O. Box 586
Buffalo, N.Y. 14226
Fax: 716-874-4508
www.AmherstMedia.com

Publisher: Craig Alesse
Senior Editor/Production Manager: Michelle Perkins
Assistant Editor: Barbara A. Lynch-Johnt

ISBN: 1-58428-060-3
Library of Congress Card Catalog Number: 2001 132046

Printed in Korea.
10 9 8 7 6 5 4 3 2 1

Notice of Disclaimer: The information contained in this book is based on the author's experience and opinions. The author and publisher will not be held liable for the use or misuse of the information in this book.

Table of Contents

Introduction

As Henry David Thoreau keenly watched the brilliant dance of sunlight on the surface of Walden Pond, Massachusetts, more than 150 years ago, he marveled at what he called "the finest imaginable sparkle" of the light on the water. He compared the beauty of Walden Pond's surface to molten glass. Photography was still in its infancy in Thoreau's Walden days, and we can only imagine the natural wonders he saw. But today we can use photography to record the wonderful sparkle that catches our eyes wherever sunlight meets water, whether it is on Walden Pond, a wild river, a quiet marsh, or a creek in a local park.

Environmental scientists understandably refer to Earth as the water planet. After all, water covers more than 70% of the planet's surface, and Earth's millions of life forms, from periwinkles to pelicans to people, are dependent on water for survival. Given the abundance of liquid water at the Earth's surface, the myriad beautiful forms that water takes on, and the dynamic interplay between light and water, it is not surprising that water—especially moving water—is an extremely popular subject for outdoor photographers. This book is designed as a guide to field techniques and a source of inspiration for outdoor enthusiasts of all abilities, ages and experience levels who are interested in landscape and nature photography.

The five sections each focus on a major water photography theme: running water, still water, waterfalls, reflections and abstracts of water, and seashores

These five themes are developed through a series of photographic examples. The creative process, equipment and techniques by which I produced each photo are described. I used a 35mm SLR camera for most of the photographic examples; instances in which I used a medium-format (6x7cm) camera are noted.

In many cases I have included a comparison of two or three photos to illustrate the decisions photographers make about technique, composition, or equipment. Given the design and format of the book, you can either read the chapters sequentially or skip around based on your interests.

To aid your understanding, the glossary at the end of the book defines basic photographic terms. You will find the glossary particularly helpful if you are not already familiar with photo equipment terminology and manual exposure control. There is also an appendix that contains a section on how to protect and maintain your camera equipment when photographing water, information about three excellent locations for photographing waterfalls, and notes on the photographic equipment I use. For further explanation of the fundamentals of outdoor photography, please see my previous book, *Essential Skills for Nature Photography* (Amherst Media).

Photographing water with pleasing results is largely a matter of practice, patience and persistence. Once you know the basic photographic techniques, the quality and meaningfulness of the images you preserve on film will be as good as your equipment, your creativity, and your willingness to put in lots of wonderful hours observing nature and searching for compelling scenes, dramatic lighting, and memorable outdoor experiences.

Good luck with your photographic pursuits! Enjoy those long, golden hours as you watch "the finest imaginable sparkle" of sunlight on water, while you produce your finest imaginable photos.

Running Water

PHOTOGRAPHING

RIVERS AND

STREAMS

Horizontal or Vertical?

Technical Specifications:

SETTING: South Branch Potomac River, Grant County, West Virginia, October afternoon
LENS: 28mm
FILM: Fujichrome 50
EXPOSURE: 1/90 second at f/8 (horizontal), 1/60 second at f/9.5 (vertical)

This pair of riverscapes illustrates a fundamental choice you face each time you compose a photograph with a 35mm camera: Do you want to create a horizontal or a vertical composition? Most outdoor photographers take far more horizontals than verticals, but linear subjects like rivers and streams often work well as vertical images. In many instances, a landscape has such a strong horizontal or vertical "feel" to it that the best orientation is obvious. In other cases, such as this one, the preferable orientation is not as evident, and you may benefit from composing and shooting at least one horizontal exposure and one vertical exposure, as I did in this situation.

I was drawn into this scene to the extent that I set up my tripod in the shallows of the river. I use a tripod with spiked feet that firmly anchors the tripod legs in sandy or muddy stream bottoms. While in the water with the camera and tripod, I keep the camera strap wrapped around my arm so that if the tripod is tipped by the current in the stream, the camera stays dry.

In both images, I chose to place the horizon high up in the photo, approximately 1/4 of the way down from the top. This allowed me to include more of the river and some prominent rocks in the foreground, thus strengthening the visual impact of the foreground and enhancing the sense of depth in the photo. Compare the two photos in terms of how your perception of the scene is affected by the positioning of the rocks in the foreground and the forested ridge in the background. Do you prefer horizontal or vertical?

Quick Tip

Face upstream to create strong vertical compositions of rivers and creeks.

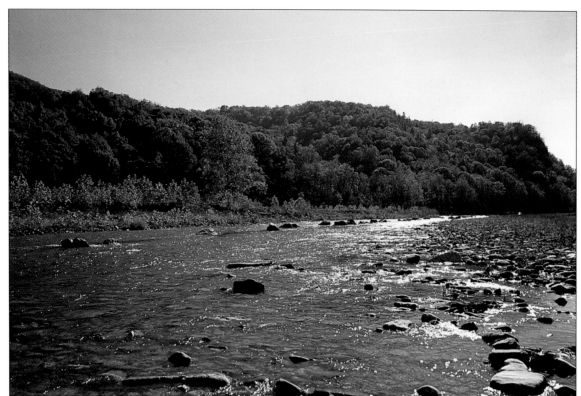
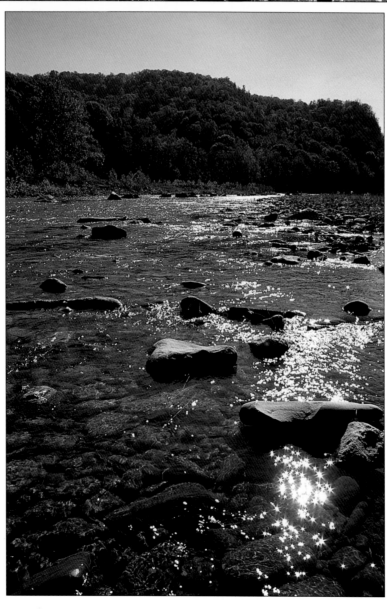

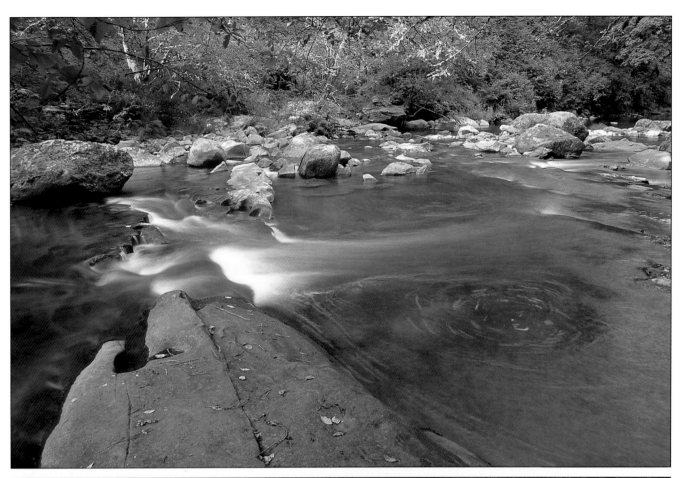
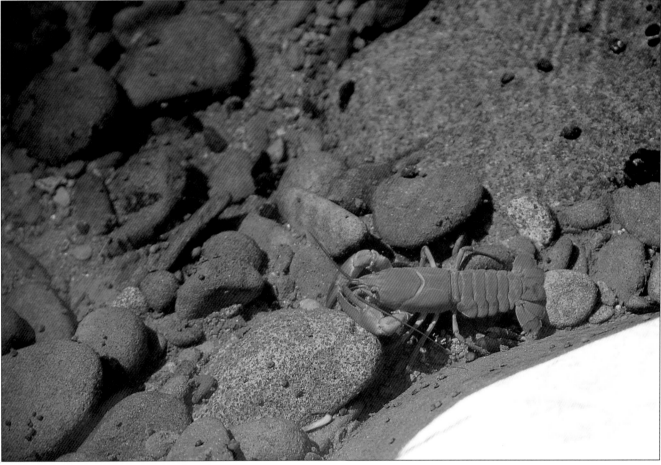

Technical Specifications:

SETTING: Drift Creek Wilderness, Siuslaw National Forest, Oregon, August morning

LENS: 28–200mm zoom set at 28mm (top), 28–200mm zoom set at 200mm (bottom)

FILM: Fujichrome 100

EXPOSURE: 4 seconds at f/22 (top), $\frac{1}{90}$ second at f/5.6 (bottom)

These two photos of a pristine salmon-spawning stream in Oregon's Coast Range illustrate the importance of judicious choice of shutter speed to control the appearance of motion in photographs of both running water and wildlife.

The first photo (top), which offers a cross-stream view of a little white-water riffle, shows the expected result of using a slow shutter speed—in this case, four seconds—for a photo of running water. Four seconds is a very long time photographically. During this period, a lot of water moved downstream through the view of my lens. The film "saw" and recorded all the motion that occurred while the shutter was open. Thus the creek surface appears smooth, particularly in the areas of white water.

Notice also how the film captured the motion of water flowing clockwise in an eddy in the lower right part of the image. Part of the joy of taking long exposures is the ever-present element of surprise; interesting visual details such as this eddy, which I did not see with the naked eye, often appear unexpectedly in your photos. Keep in mind that there is a potential drawback to using slow shutter speeds; had there been a breeze rustling the leaves, they would have been blurred in the photo.

I took the second photo (bottom) in a relatively still, sunlit pool along the creek bank a short distance upstream from the first image.

Admittedly, when it comes to swiftness in the animal world, crayfish are hardly competitive with gazelles and cheetahs! But nonetheless, shutter speed is still an important consideration here. Even when you are photographing a small, slow-moving animal, if the animal occupies a sizable portion of the image, you risk blurring it if you choose a slow shutter speed. In this instance, I opened the lens up to f/5.6, which gave me a shutter speed of $\frac{1}{90}$ second; this was sufficient to freeze the motion of the crayfish. A slower shutter speed would have yielded a blurry crayfish. When photographing small animals in water, try to get as close as possible, and watch out for reflections on the water surface; use a polarizer to reduce the reflections if necessary.

Quick Tip

A tripod is an indispensable accessory for photographing running water since it allows you to use long exposures to record motion.

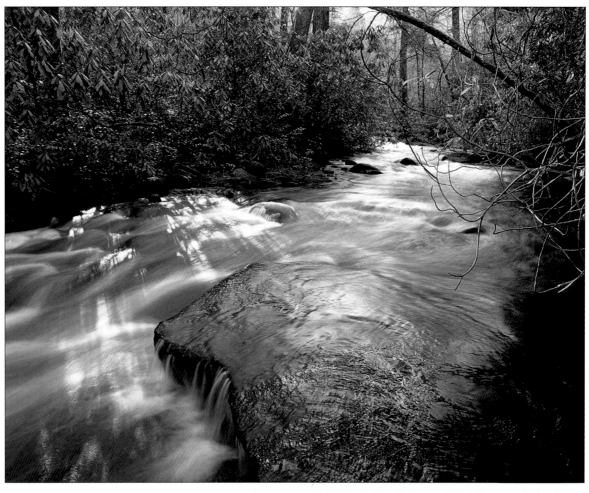

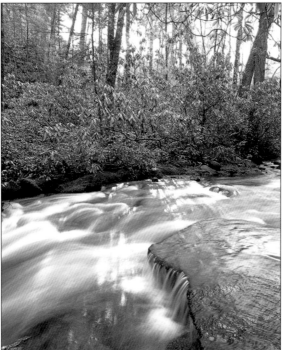

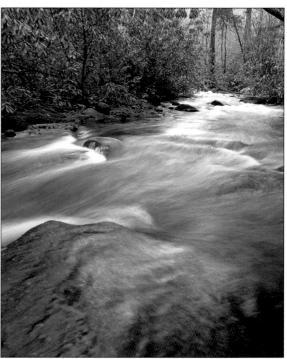

Work with the Scene

Technical Specifications:

SETTING: Little Santeetlah Creek, Joyce Kilmer-Slickrock Wilderness, Nantahala National Forest, North Carolina, December afternoon

LENS: 45mm on medium-format (6x7cm) camera

FILM: Fujichrome 100

When I approach a river or stream to photograph, I rarely see the potentially best compositions at first glance. I like to wander up and down the stream banks for at least ten to fifteen minutes before I even begin to photograph. During this time I am physically slowing down, while mentally sharpening my focus on the surroundings. I scan the area both with the naked eye and through the viewfinder. Contemplating a few questions helps me clarify my photographic intentions:

- What natural features define the character of this place?
- What is visually interesting about this landscape?
- What draws me to this scene?
- What do I most want to communicate in my photos of this location?

This trio of photos shows three wide-angle views of a small, fast Appalachian Mountain creek. The angle of view of a 45mm lens designed for a 6x7cm medium-format camera is approximately as wide as that of a 22mm lens on a 35mm camera; in other words, it takes in a very wide view. Each photo has unique compositional elements. The first photo (top) is framed horizontally and incorporates a tangle of bare rhododendron branches on the right side. The second photo (bottom, left) makes use of the bright, contrasty sky for an airier

look. Notice the role that the large, flat rock in the foreground plays in these two images. In the third photo (bottom, right), I moved into the scene and changed the composition significantly by setting up my tripod on top of this rock.

For each of these photos, I stopped the lens down to f/22 to maximize the depth of field or front-to-back zone of sharpness in the photo. Using such a small aperture also allowed me to lengthen the shutter speed to a large fraction of a second to record more water motion.

Quick Tip

When photographing running water, take your time. Slow down and stay in one place long enough to develop several good compositions.

Pastoral Perspective

Technical Specifications:

SETTING: Connecticut River, Mount Sugarloaf State Reservation, Massachusetts, September afternoon

LENS: 75–300mm zoom

FILM: Fujichrome 100

Unlike most of the photos in this book, this image shows a landscape that has clearly been shaped by several centuries of settlement and agriculture. The Connecticut River Valley is a patchwork of farms, fields, forests and picturesque New England towns dating from the Colonial era. The low-angle sunlight of late afternoon provides strong side lighting and long shadows that give added texture and body to this pastoral scene of the Massachusetts countryside.

This photo is a good example of the strength of aerial perspective, of the power of photographing the landscape from above. I took this exposure in early autumn from a vantage point more than 500 feet above the river on South Sugarloaf Mountain. The gracefully curving Connecticut River, reflecting a partly cloudy sky, serves as a key compositional element here. Notice how your eyes follow the shoreline from the lower left up into the center of the picture, and how the river ultimately leads you to the forested hills in the background.

Small, discernible objects that contrast with the background often make nice accents in landscape photos. In this instance, a number of light-toned homes and barns pepper the patchwork of the landscape nicely. Though tiny and distant, the hot-air balloon at upper left adds one more accent in keeping with the mood of floating time and the peaceful river.

Quick Tip

Consult topographic maps and hiking guidebooks to find high points with unobstructed river views.

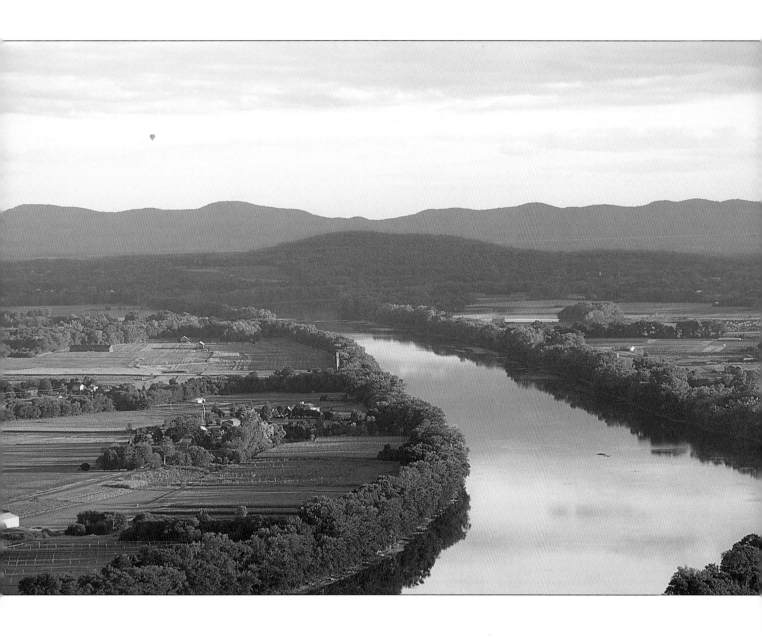

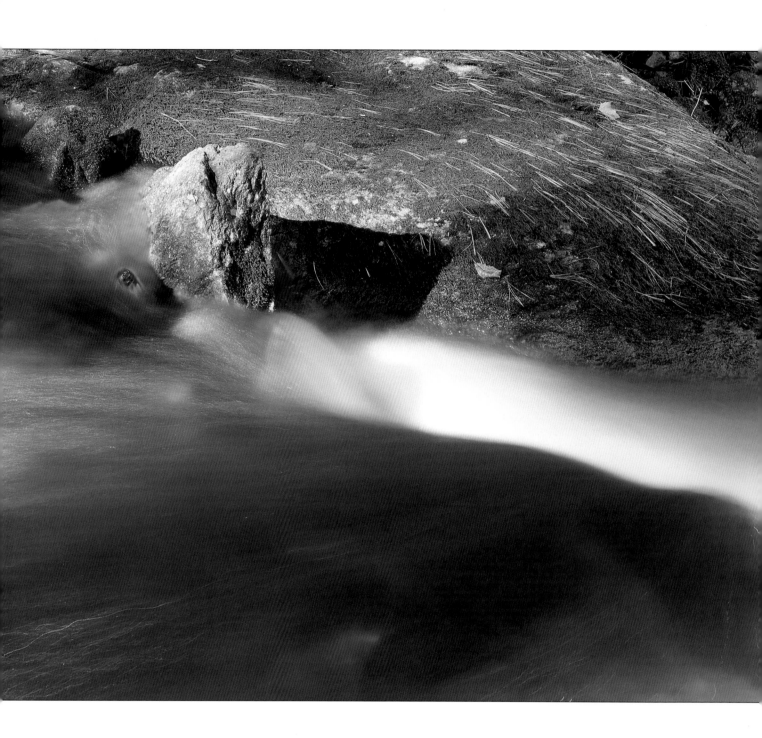

Get Closer

Technical Specifications:

SETTING: Ginger Creek, Campbell Falls State Park, Connecticut, October morning

LENS: 135mm on medium-format (6x7cm) camera

FILM: Ektachrome 100

EXPOSURE: 7 seconds at f/32

Moving in close to your subject is advantageous when your goal is to produce captivating photographs of running water. For this autumn morning portrait of fast-running Ginger Creek on the Connecticut-Massachusetts border, I set up my tripod at the water's edge, and left the tripod legs in their most compact position. I chose a short telephoto lens—a 135mm lens on a 6x7cm medium-format camera has approximately the same angle of view as a 65mm lens on a 35mm camera. After scanning up and down the creek to find an aesthetically pleasing composition, I settled on this close-up view of the creek.

Quick Tip

A short telephoto focal length is frequently ideal for portraits of small streams.

The fallen pine needles in the upper part of the photo are an important compositional element in this image. They were deposited and aligned on the moss-covered boulder by falling flood waters hours earlier after a heavy rainfall. Notice how both the pine needles and the faint streamlines on the surface of the water in the foreground lead your eye to the right toward the white-water area.

This was a fairly straightforward scene for judging exposure, since much of the image was made up of medium-toned greens and browns. The streak of white water and the sunlit highlights on the pointed rock in the upper left part of the image were light enough that I chose to overexpose by $\frac{1}{2}$ stop relative to my exposure meter reading for the full scene so that I would not lose detail in the darker parts of the image. I stopped the lens down to f/32 to maximize the depth of field in an effort to sharply reproduce as much of the scene as possible.

What Does a Polarizer Do?

Technical Specifications:

SETTING: Glacier Creek, Rocky Mountain National Park, Colorado, August afternoon

LENS: 28–70mm zoom set at 70mm

FILM: Fujichrome 100

EXPOSURE: 1 second at f/27 (top), 6 seconds at f/27 with polarizing filter (bottom)

A polarizing filter, also known as a polarizer, is one of the accessories most widely used by professional nature photographers. It can reduce or eliminate reflections from water, leaves, slick rocks and other shiny surfaces; it can increase the contrast between clouds and sky, and deepen the sky color; and it can enhance the overall color intensity of a scene.

To test the effects of a polarizer, I photographed a small slice of Colorado's Glacier Creek both with and without a polarizing filter. Note in the second photo (bottom) how the polarizer radically changed the appearance of both the water surface and the rock at right center, toning down the bright highlights caused by reflection of direct sunlight.

The silky appearance of the water surface in both photos was created by the rapid motion of the creek and the long exposure times. This effect is accentuated in the polarized image by the substantially longer exposure time, six seconds versus one second.

When using a polarizing filter, keep the following three points in mind:

1. The polarizer will have greatest effect on the scene when your camera's line of sight is at a right (90°) angle to the sun; the effect is progressively diminished as you turn either toward or away from the sun from this perpendicular position.

2. The polarizer's ability to reduce reflections from a water surface is maximized at the point at which your camera is facing at a 35° angle in relation to the water surface.

3. By rotating the polarizing filter in its mount, you can substantially alter the degree of impact that the polarizer has on the scene. The maximum alteration of the scene with a polarizer is not always desirable, and may in fact create a decidedly unnatural looking image.

Quick Tip

When photographing running water, take along a polarizing filter to expand your creative possibilities.

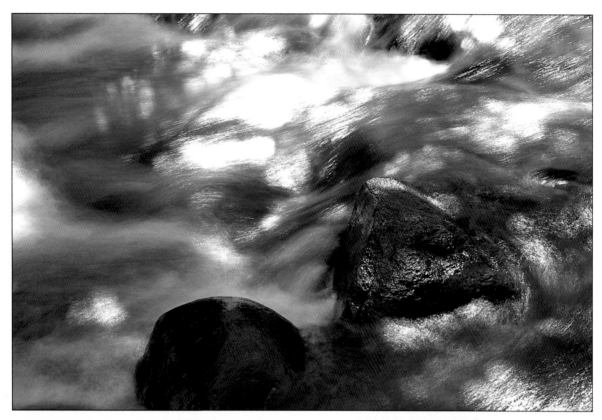

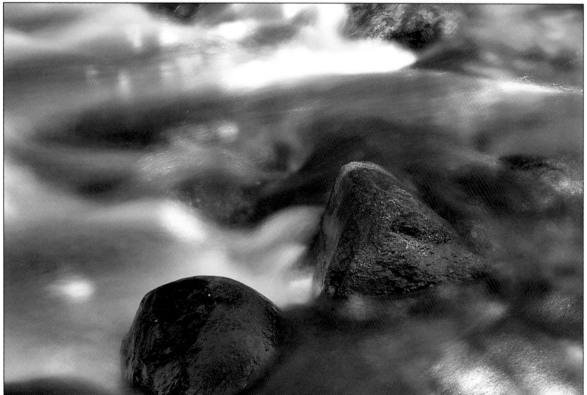

Polarized Streamscape

Technical Specifications:

SETTING: Elk Creek, Tillamook State Forest, Oregon, April afternoon

LENS: 28–200mm zoom set at 28mm

FILM: Fujichrome 100

EXPOSURE: 0.7 second at f/22 (left), 1.5 seconds at f/22 with polarizing filter (right)

This is another field test of a polarizing filter, this time on a cloudy day. Outdoor photographers most often consider using polarizing filters on sunny days, but polarizers can also be a valuable accessory in overcast conditions. I took these two photos from a bridge spanning the stream to get a bit of an aerial perspective for a strong vertical composition.

As the second photo (right) shows, in this situation the polarizer removed the white-sky reflections from the surface of the stream and from some of the prominent rocks, while leaving the true white water visible in the riffles. The tone of the moss-covered stream bank was also deepened. Less noticeable, but nonetheless significant, is the way in which the polarizer reduced the reflections on the leaves and fern fronds, particularly at the right side of the photo.

Quick Tip

If you protect your wide-angle lens with a UV or skylight filter, remove that filter before attaching a polarizer to avoid vignetting.

I chose an aperture of f/22 both to maximize depth of field, ensuring front-to-back sharpness, and to lengthen the exposure time to capture more of the creek's motion. Note that in the second image the polarizer caused a one-stop reduction in light reaching the exposure meter. Therefore, I doubled the shutter speed from 0.7 second to 1.5 seconds at f/22.

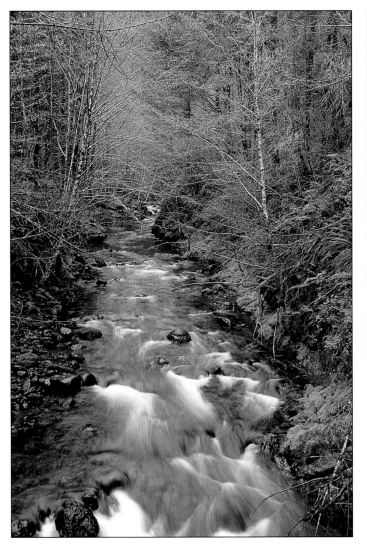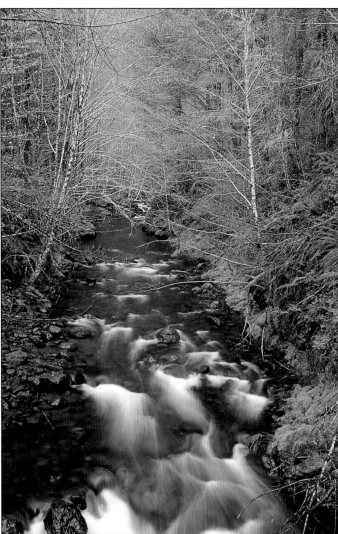

Perspective, Perspective, Perspective

Technical Specifications:

SETTING: Clackamas River, Mt. Hood National Forest, Oregon, July afternoon

LENS: 28–70mm zoom

FILM: Fujichrome 100

I took this pair of photos while walking upstream along the rocky banks of Oregon's lively Clackamas River in the foothills of the Cascade Mountains. Though the two images include much of the same stretch of river, they have a markedly different look from one another, and it is useful to examine why this is the case.

The first photograph (left) has a strong, textured foreground dominated by the massive bedrock and jumble of broken rocks of the riverbank. This photo has four well-defined compositional zones from bottom to top: the riverbank, the river, the forest and the sky. The zones have distinct colors, textures, tones and shapes that add visual appeal to the image.

Quick Tip

For greater visual appeal, compose your photos with your camera at any height other than your normal eye level when standing.

After taking the first exposure, I repositioned myself near the middle of the first image to compose the second photo (right). This time I excluded the bottom riverbank zone, which is an important element in the first photo. Instead, I used the rushing white water itself as the foreground; in fact, the river fills the whole lower half of the photo.

To emphasize the power and velocity of the river's current in the second photo, I set up my tripod right at the water's edge. I chose not to extend the legs of the tripod, thus keeping the camera at a very low position. This gives the viewer the sense of looking up at the river, a strikingly different perspective than in the first photo. A major element of producing interesting nature photos is simply seeking out unusual or creative perspectives.

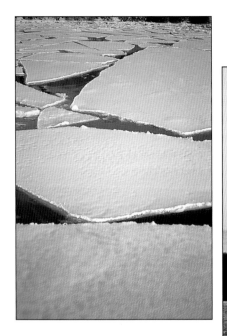

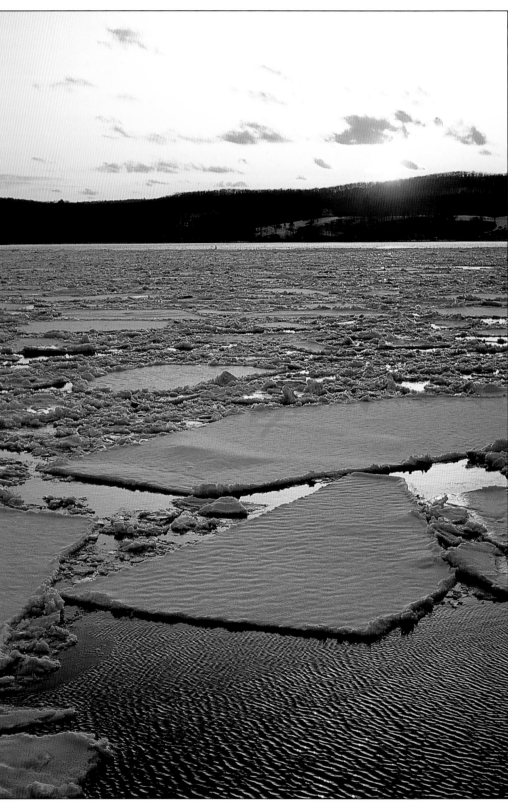

Spring Thaw

Technical Specifications:

SETTING: Hudson River, Mills-Norrie State Park, New York, March afternoon

LENS: 35mm

FILM: Fujichrome Velvia (ISO 50)

The spring ice breakup on northern rivers affords great photo opportunities. As with so many other natural events, the timing and rapidity of the ice breakup varies from year to year, but the astute nature observer is rewarded with the sights, sounds—and, hopefully, good photographs—of this annual phenomenon. On the first mild days of March, the icy Hudson River starts to creak and groan as the winds, currents and tides begin to break the winter's ice apart and thus create a constantly shifting riverscape. Depending on weather conditions, this process may be completed in several days or it may stretch out for weeks of thawing and refreezing.

Late on a March afternoon as the sun approached the western horizon, I took this pair of photos from a point of land that juts out from the east side of the river. In the first composition (left) I emphasized large, sunlit ice cakes. The textured, snowy surface of these ice polygons, the narrow channels between them and the thin strip of the east bank of the river at the top of the image are all key elements in this image. I was aiming the camera downward just in front of my feet to get as much of the foreground ice block in the image as I could.

The second photo (right) features the setting sun, its light dimmed by a passing cloud. This diffuse sunlight worked wonders as it lit up the scattered slices of open water. I positioned the horizon about one-fourth of the way down from the top of the photo so as to place prime emphasis on the river. Again, texture is important here, particularly the ripples in the foreground and the surface of the large ice cakes near the center of the photo. This photo captures the season, recording the moment, a day and a time that comes only once each year as the ice breaks up.

Quick Tip

Keep a journal of natural events in your bioregion so that you can plan ahead for seasonal photo opportunities.

A Wider View

Technical Specifications:

SETTING: Savage River State Forest, Garrett County, Maryland, October afternoon

LENS: 17mm

FILM: Fujichrome 50

EXPOSURE: 1 second at f/16

While photographing autumn foliage in Maryland's Allegheny Mountains, I came upon this tiny stream tumbling down over a series of moss-covered rock shelves into a small pool. The little creek was not visually striking, so I chose to move in very close to the pool and use an ultrawide-angle 17mm lens to photograph. The very wide 104° angle of view of this lens allowed me to include much of the environmental context of the stream.

Quick Tip

Once you have composed an image, consider how your choices of aperture and shutter speed will each affect the appearance of your photo.

In both the horizontal and the vertical compositions, the focal point is below the center of the image where the white water spills into the pool. The viewer's eye is led toward this focal point by the edges of the pool near the bottom of the image, the hillsides sloping downward from the left and right, and a number of fallen limbs and logs. Composing the scene vertically allowed me to add important elements in the upper and lower parts of the image that did not fit in the horizontal composition. The sun, which appears star-like because of its diffusion by the trees, adds a secondary focal point at the upper left. The rhododendron leaves at the upper right add a nice accent, while also blocking from view a washed-out background of sunlit foliage. The rocks at the lower right provide another secondary focal point in the foreground, thus helping give the vertical image a deeper feel than the horizontal composition.

The slow shutter speed I used, one second for each exposure, enhanced the appearance of the creek by smoothing and softening the look of the moving water. Also, by capturing a full second of stream flow, the film records more water than the eye sees in any one place at any one instant, in essence bulking up the complexion of the stream to add to its visual appeal.

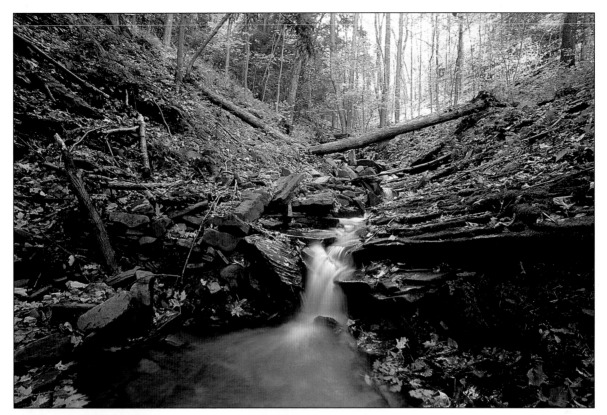
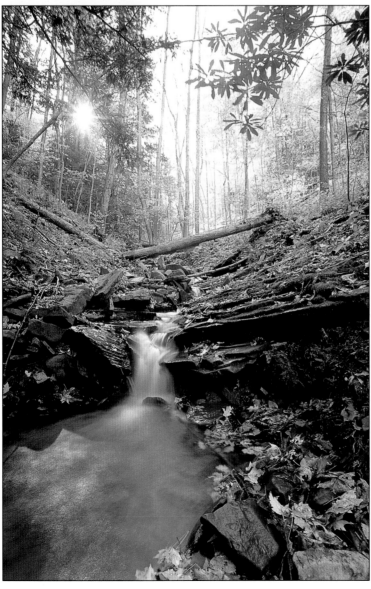

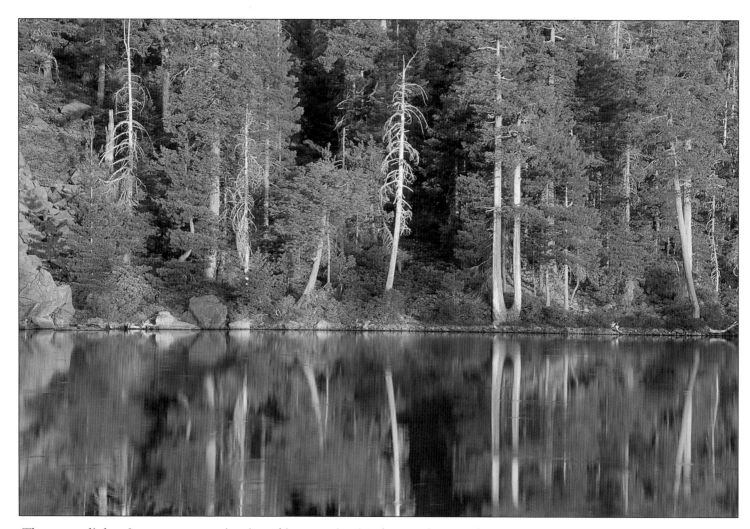

The warm light of a summer sunrise tints this portrait of Vulcan Lake in Siskiyou National Forest, Oregon. The vertical lines of the light-toned tree trunks are visually prominent in the softly blurred reflections. (28–200mm zoom lens set at 90mm; Fujichrome 100; exposure: ½ second at f/16)

Still Water

PHOTOGRAPHING
LAKES, PONDS
AND WETLANDS

Early Morning Peace

Technical Specifications:

SETTING: Promised Land Lake, Promised Land State Park, Pennsylvania, October sunrise

LENS: 17mm

FILM: Fujichrome 100

Many of the most memorable nature images are photographed around the time of sunrise or sunset. Why? The world is quiet, the light is warm, shadows are long, wild animals are active, people are either commuting or eating, and lakes and ponds are often nearly still.

I rose at daybreak to photograph this late October sunrise in the Pocono Mountains. I chose an ultrawide-angle 17mm lens to take in a broad view of the placid landscape. The first photo shows the sun just as it was climbing over the horizon across the lake. The starburst effect frequently occurs in photographs when the sun is partially obscured. I tried to create harmony in this photo by balancing sky and water. The tangle of almost-bare branches adds character to the sky, while ripples and reflections give the lake surface texture. The dark foliage at the right side of the photo provides a nice mass to counter the airiness of the remainder of the image.

Notice in the first photo (top) how the off-center position of the sun—about one-third of the way across the image from left to right and one-third of the way up from the bottom of the photo—works well. This is an illustration of the traditional photographic rule of thirds in which an image is composed with the most important subject or subjects located at the intersections of an imaginary tic-tac-toe grid superimposed on the scene.

I made the second photo (bottom) only a few minutes—and six quick exposures—after the first photo. Already the sun was becoming overpoweringly bright and thus difficult to work with as a photographic subject, so I walked a short distance along the lakeshore to find a suitable view to the north that excluded the sun. In this image, the slice of sunlit lakeshore at the lower left makes an interesting foreground, and the trees and foliage on the left side frame the view of lake and sky. The beaver swimming into the center of the photo is not big enough to be significant in this wide-angle view, but its V-shaped wake adds a nice accent. Little things do add up to make memorable photos.

Quick Tip

Consider the rule of thirds as a guideline to break the habit of centering your photographic subjects.

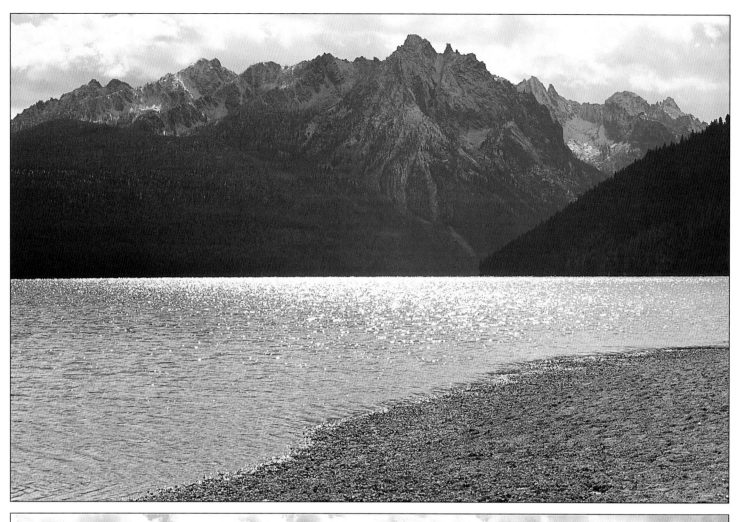

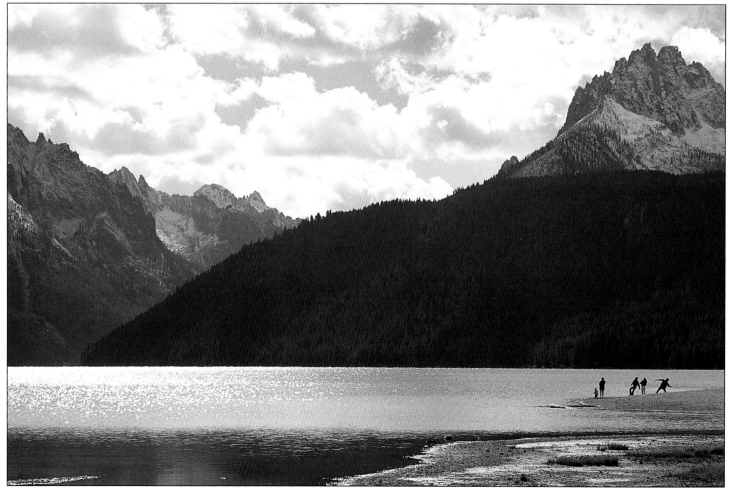

Add Life to Landscapes

Technical Specifications:

SETTING: Redfish Lake, Sawtooth National Recreation Area, Idaho, October afternoon

LENS: 90mm

FILM: Fujichrome 50

Time and again, the presence of people adds an element of interest to landscape photographs, a fact that has not been lost on the editors at *National Geographic* over the years. Even people that appear extremely small in a vast landscape, occupying only a tiny portion of the image, can significantly enhance a landscape photo. This is particularly true if the people stand out from the background; a red sweater may be a photographic cliché, but it really does show up!

These two images are the visual harvest of a glorious autumn afternoon in Idaho's aptly named Sawtooth Mountains. The first photo (top) emphasizes the lake and the jagged, snowy mountains. The beach in the foreground gives a greater sense of depth to the photo by figuratively anchoring the bottom of the image. Note how the features in the upper right portion of this photo appear in the left side of the second photo (bottom). I altered the composition in the second photo to bring the landscape alive by including a group of people skipping stones from the lakeshore. I took several of these candid shots to yield this one good image in which none of the individuals overlapped one another and in which the action was interesting even from a distance. The people show up well in this photo because they appear dark against the light-toned water behind them.

Both photos were intentionally overexposed ½ stop compared to the exposure suggested by the camera's center-weighted exposure meter. This overexposure is to compensate for the light-toned sky and sunlit water that make up a significant part of both images.

Quick Tip

Look for opportunities to enliven your landscape photos by including people.

Cattail Tales

Technical Specifications:

SETTING: Fernhill Wetlands, Forest Grove, Oregon, August morning

LENS: 75–300mm zoom set at 300mm

FILM: Fujichrome 100

EXPOSURE: $\frac{1}{90}$ second at f/16 (top), $\frac{1}{250}$ second at f/5.6 (center), $\frac{1}{8}$ second at f/27 (bottom)

I took this trio of images on a summer morning walk along an Oregon cattail marsh. Given the characteristic flatness and openness of marshes, a lot of wetlands photography is done with wide-angle lenses; these three photos illustrate the alternative approach of using a telephoto lens to pick out smaller details within a marsh. Note how each of the three images treats the relationship between cattails and water in a substantially different way.

The first photo (top) is a backlit silhouette dominated by water. The textured sheen on the marsh surface, which bears a strong resemblance to snow or ice, was actually produced by the morning sun reflected off of floating algae that blanketed the surface of the water. In silhouette, the cattail stubble left behind from the previous year appears as a series of vertical lines. These lines provide just enough visual appeal to make the photograph interesting, and to prevent it from being purely abstract.

Quick Tip

Consciously make good use of lines—straight, curved, horizontal, vertical and diagonal—to create appealing photos.

The gentle curves of dozens of cattail blades, some sunlit and some in shade, are the primary focus of the second image (center). This photo illustrates the aesthetic power of diagonal lines. The out-of-focus water surface merely provides a light, simple background for the cattails. My choice of exposure here was predicated by a breeze that kept the cattails in constant motion. I selected a shutter speed of $\frac{1}{250}$ second to freeze the moving cattail blades in sharp focus.

In the third photo (bottom), both cattails and water play major roles. Photographed from a few feet above the marsh level, this image is largely a study in vertical lines. Several diagonals and curved lines stand out from the verticals, and provide nice accents. The water surface has a stained-glass appearance because of the combination of algae and cattail reflections in the water.

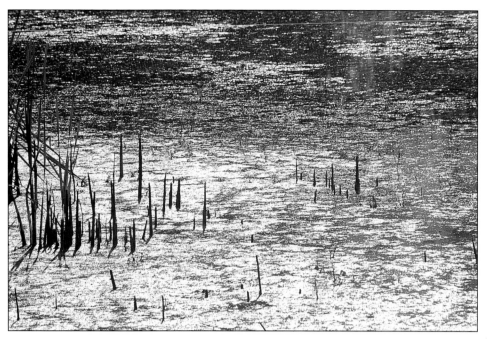

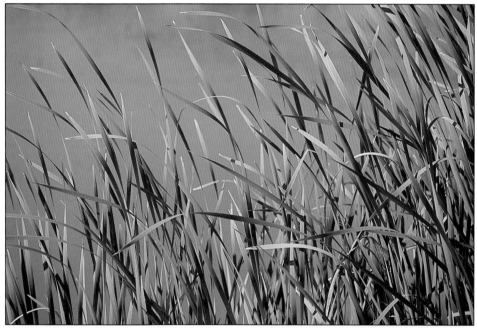

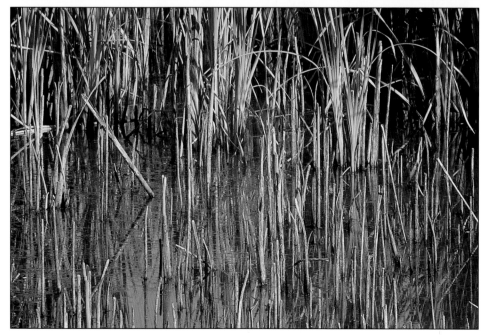

Sun and Symmetry

Technical Specifications:

SETTING: Bhawal National Park, Gazipur, Bangladesh, November afternoon

LENS: 35mm

FILM: Fujichrome 50

I composed this photo in the late afternoon as the sun sank over a small lake in a tropical forest preserve in central Bangladesh. This image is a simple study in symmetry and contrast, relying on the interplay of sunlight and dark shadows.

The first rule of outdoor photography that many people learn is to not take photos while facing the sun. Like virtually all photographic guidelines, this rule is good advice some of the time. After all, when you use your camera's automatic exposure ("program") mode, if you include the sun's overwhelming brightness in your composition, the result may be gross underexposure of the image. Or if you manually compensate for this underexposure, the sun may appear as a super-bright, washed-out blob that dominates the image. But on many occasions, the sun's brightness is reduced by haze or thin clouds to the point that the sun itself can be a positive element in your photos. Keep in mind that your camera's viewfinder does not protect your eyes from the sun.

In this instance, I carefully positioned the sun and its reflection in the upper center part of the image to create a photo that has pleasing symmetry. I moved along the lakeshore until I reached a point where the sun lit up the lily pads enough that they would become a focal point in the composition. The sun is partially diffused by clouds above the horizon. The sun's influence still results in underexposure—since I chose to use my metered exposure—to the extent that much of the scene is black. This darker image works well here, excluding extraneous detail and leaving a more elemental rendition of the scene.

Quick Tip

By walking along a lakeshore, you can often improve compositions by altering the position of the sun's reflection in the water.

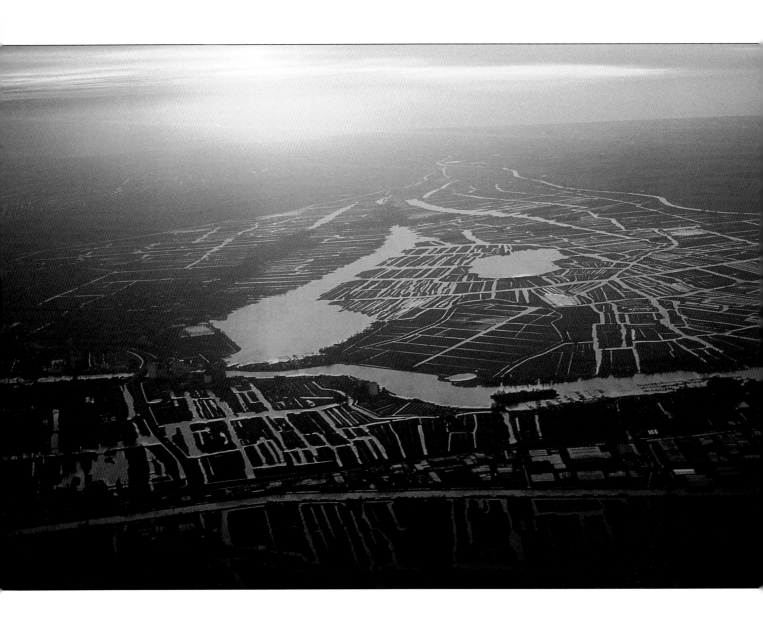

Technical Specifications:

SETTING: Netherlands, March sunrise

LENS: 28–70mm zoom

FILM: Fujichrome 50

I took this photo near the end of an all-night flight from Atlanta to Amsterdam. As we flew across the Dutch coastline, the sun was just climbing over the horizon to light up the stunningly flat, water-rich landscape of the Netherlands. The low-angle, direct sunlight coming through bands of high clouds richly illuminated the intricate network of canals, ponds, marshes and rivers with pastels. This intensively engineered landscape, reshaped over the centuries to serve agriculture, industry and shipping, had its own brand of beauty in the early morning light.

As is typically the case with aerial photography from commercial airliners, I had to make quick decisions to get this photograph. I simply framed the scene as rapidly as possible, making sure that I was not including parts of the aircraft or edges of my window in the composition. I took a light reading off of the central part of the scene using my camera's spot meter, knowing that otherwise the sun's brightness would fool my exposure meter into significant underexposure of the much darker land. I managed to click off three exposures before the sun disappeared back into the clouds.

Two of the keys to aerial photography—assuming you cannot open your window (which is strongly discouraged on most commercial flights!)—are to place your lens as close to the window as possible and to make sure the front of your lens parallels the window. Otherwise, reflections and distortion become problematic. Beyond that, make sure you have adequate shutter speed to freeze the rapid motion of the land—several hundred miles an hour—relative to the aircraft. A shutter speed of $1/250$ second or faster is desirable, especially at lower altitudes.

Quick Tip

In difficult exposure situations, use your camera's spot meter to read the light off of the most important subject that is in your composition.

Look Both Ways

Technical Specifications:

SETTING: Coldwater Lake, Mt. St. Helens National Volcanic Monument, Washington, February afternoon

LENS: 135mm on medium-format (6x7cm) camera

FILM: Ektachrome 100

I made this pair of photos on a sunny winter afternoon in the blast zone of Mt. St. Helens. Coldwater Lake was formed in the aftermath of the volcano's 1980 eruption when an enormous debris avalanche effectively dammed Coldwater Creek. This beautiful lake is surrounded by a ghostly landscape where lush evergreen forests were transformed in seconds into a post-apocalyptic jumble. Large expanses of dead timber still stand as a mute reminder of the eruption.

I took the first image (left) while looking eastward from the west end of the lake. I was struck by the blueness of the water accented by the abundant floating driftwood and the reflection of the snow-covered mountainside. I chose a vertical composition with a short telephoto lens to include a lot of the driftwood in the foreground as well as the mountains and a bit of sky in the background. The scene is front-lit by the afternoon sun. I overexposed the scene slightly, by ½ stop, compared to my exposure meter reading to compensate for the fact that the upper third of the image—sunlit snow and sky—is much lighter than the medium gray tone for which exposure meters are calibrated.

As an outdoor photographer, when you feel you have exhausted the possibilities with one subject, you can frequently find something else that is visually compelling by simply looking closely at your surroundings. To compose the second photo (right), I turned around to face the sun and walked a short distance before backlit driftwood caught my eye. My goal was to "fill the frame" of my viewfinder with the floating driftwood in a marshy area at the edge of the lake. In such instances, I put the camera on the tripod, then I pan and tilt the camera until I come up with a composition that catches my eye. I was particularly drawn to the sparkle of the late afternoon sun on the wet driftwood. Due to the very strong, oblique backlighting, this scene was much lighter in tone than a medium gray, thus I again overrode my exposure meter by opening up the aperture, this time by a full stop.

Quick Tip

To find interesting photo compositions, look carefully in all directions for striking details within the landscape.

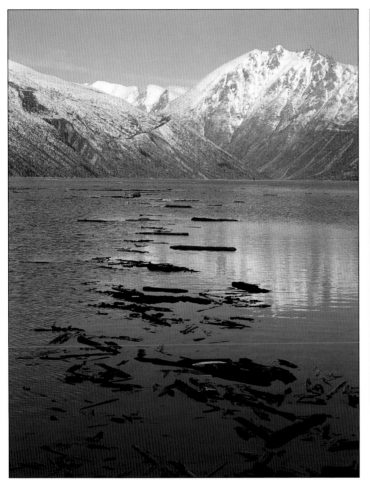 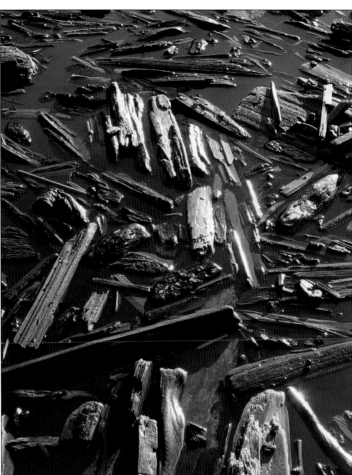

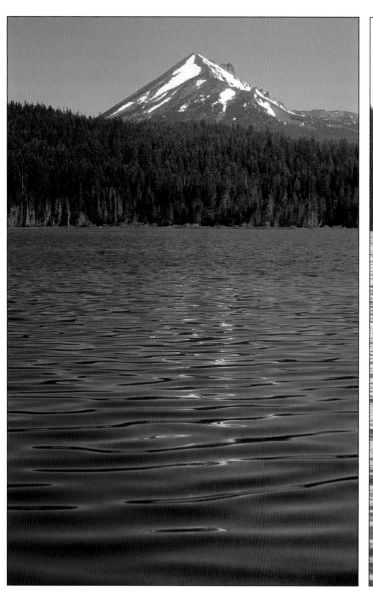
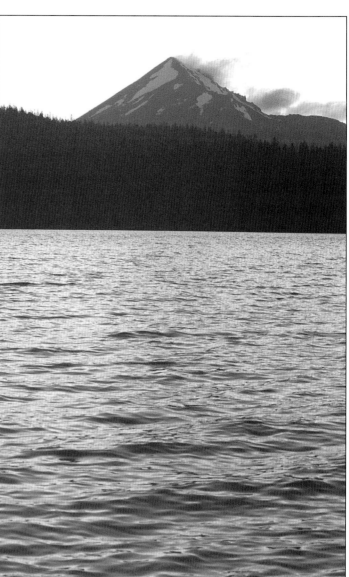

Technical Specifications:

SETTING: Lake of the Woods, Winema National Forest, Oregon, July morning and evening

LENS: 75–300mm zoom set at 75mm

FILM: Fujichrome 100 (left), Fujichrome MS 100/1000 pushed to ISO 1000 (right)

This pair of photos of Lake of the Woods and Mt. McLoughlin in Oregon's Cascade Mountains illustrates how ambient lighting and film characteristics affect the appearance of photos. The first photo (left) is a summer morning portrait with a clear sky. Notice how the snow and ice on the mountain's flanks stand out as the lightest tones in the scene. The second photo (right) was taken in low light well after sunset. The sky is white, the lake reflects the light from the sky, and the forested shoreline is dark.

The first photo, taken on a standard 100-speed slide film, is very sharp with almost no apparent graininess. The second image is noticeably grainy. It was taken on Fujichrome MS 100/1000, a special high-speed slide film that was "pushed." To do this, I manually set the film speed on my camera to ISO 1000 while shooting this roll of film. Then when I got the film processed, I asked the photo lab to push process the film four stops per instructions on the film packaging. This means the lab processing time of the film was substantially increased.

More commonly, normal slide films are pushed one stop by shooting them at twice their rated speeds. For example, ISO 100 film is shot at ISO 200. Pushing film costs more at the photo lab, and often noticeably increases the contrast and graininess of the resulting slides. So why push film? Slide film is often pushed in wildlife photography to allow for greater shutter speed, especially when photographing moving animals in low light. You may also push film so that you can use fast enough shutter speeds to handhold your camera steadily in very low light. A third reason for pushing film, as illustrated here, is simply to produce grainier images with higher contrast for aesthetic purposes.

Quick Tip

Experiment with a variety of films to find which ones best suit your photographic taste.

Heron Silhouette

Technical Specifications:

SETTING: Fernhill Wetlands, Forest Grove, Oregon, November dusk

LENS: 75–300mm zoom set at 300mm

FILM: Fujichrome 100

EXPOSURE: $\frac{1}{125}$ second at f/5.6

A recurring experience for every serious nature photographer is that you sometimes do not find what you were looking for on a particular photographic outing. The good news is that you frequently find something better! Late on a sunny November afternoon, I spent a couple of hours at one of my favorite local wetlands near Portland, Oregon, with two photographic objectives in mind. I had hoped to photograph a spectacular sunset, but the sun went down with barely a warm tint in the western sky. I had also hoped to photograph wintering flocks of Canada geese as they flew across the face of the moon before they settled into the wetlands for the evening. But the geese were nowhere to be seen on that particular evening.

As day was giving way to night, I still had not taken a single exposure, and I walked westward out of the wetlands to my car. Only fifty yards short of the car, I came across this elemental scene of a lone great blue heron fishing in the shallows. I took an exposure meter reading of the image as you see it, and chose to overexpose by $\frac{1}{2}$ stop so as to lighten the water a bit for better contrast. My shutter speed was $\frac{1}{125}$ second with the lens aperture set wide open at f/5.6.

I did not set up my tripod since I felt the heron, its solitude disrupted, might fly away at any moment. To successfully produce a sharp handheld exposure with this combination of a 300mm focal length and a $\frac{1}{125}$ second shutter speed was unlikely. When you are not using a tripod, a general guideline to avoid camera shake and blurred photos is to use a shutter speed at least as fast as the inverse of your focal length. So with a 300mm lens, you want a shutter speed of $\frac{1}{300}$ or faster. But sometimes, for the sake of a photo, it is well worth going beyond the limits suggested by this rule.

In this case, I quickly took one handheld exposure before the heron flew. My day was complete . . . and the photo turned out sharp to boot!

Quick Tip

Find wetlands silhouettes by looking eastward before sunrise and by looking westward after sunset.

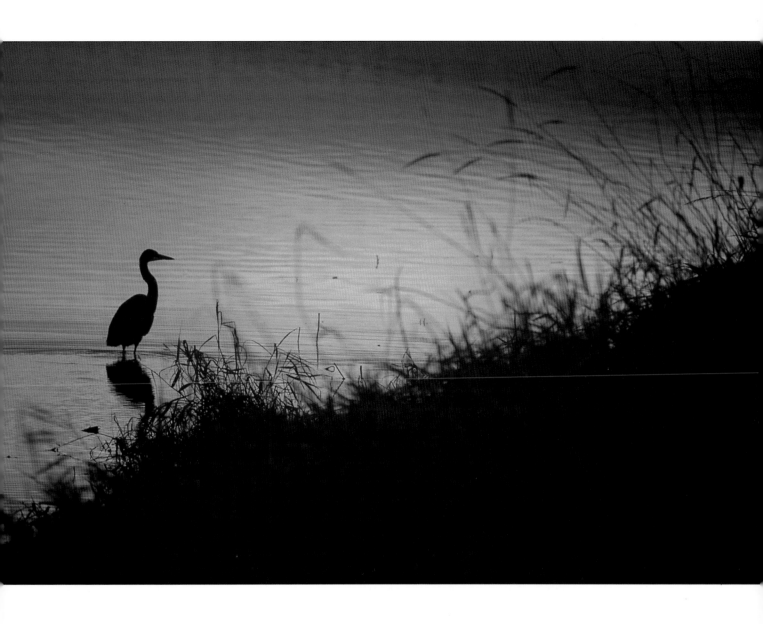

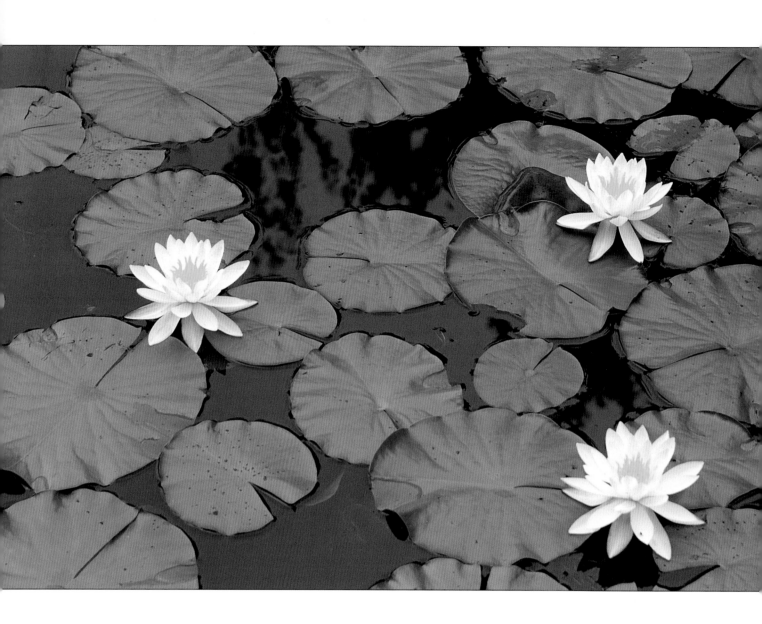

Technical Specifications:

SETTING: Prime Hook National Wildlife Refuge, Delaware, September afternoon

LENS: 70–210mm zoom

FILM: Ektachrome 100

In outdoor photography today, there is a pronounced tendency to celebrate exotic destinations, spectacular lighting and remarkable scenery. Sometimes the plain, everyday scene from your backyard or the local park is too easily dismissed as a photographic subject in its own right. This tendency to ignore seemingly mundane surroundings is unfortunate, because the places where you spend the most time are the ones that you know the best, and this manifests itself in the special quality of the photos that you can produce in your familiar surroundings. Keep in mind that ordinary places and everyday scenes can yield superb photos.

This photo of water lilies in a Delaware marsh is an example of working with a commonplace, accessible subject to produce a satisfying image. The soft light of an overcast autumn afternoon and the darkness of the water contribute to the peaceful, still-life look of this image. I used a short-to-moderate telephoto zoom lens to compose the portrait, zooming in until the size and arrangement of the three lilies was pleasing. When I compose a photo, I try to be conscious of balance, symmetry and what the viewer's eye will be drawn to in the scene. In viewing nature and landscape photos, your attention is usually drawn to the lightest tones, familiar shapes, and the areas of greatest contrast in the image. These factors all work to the photographer's advantage in composing a photo of light-colored flowers against a darker background. Take your time and keep it simple!

Quick Tip

Days that are cloudy but relatively bright often provide excellent lighting for photographing ponds, lakes and wetlands.

Frame the Lake

Technical Specifications:

SETTING: Lake Taghkanic State Park, New York, October morning

LENS: 28–70mm zoom

FILM: Fujichrome 50

One of the essential skills every good photographer must develop is the ability to effectively frame scenes through the camera's viewfinder. Some photographers have a strong intuitive sense of how to compose photos and are said to have a "good eye"; for others, composing aesthetically satisfying photos is much more of a struggle. My experiences while teaching outdoor photography for fifteen years have led me to the conclusion that virtually everyone is capable of composing photos well. The quality of your photo compositions—just like the quality of written compositions or musical compositions—is partly a matter of your sense of aesthetics, partly a matter of your photographic experience and very largely a product of the amount of time you put into the act of composing.

There are certainly outdoor photo situations, especially with wildlife, where you have to compose and expose almost instantaneously or you will miss the photo opportunity, but this is rarely the case with landscape photography. Better photo composition is within your reach if you simply put aside the urge to rapidly point and shoot. Just slow down, take some deep breaths, and give yourself time—thirty seconds or even fifteen minutes, if necessary—to critically examine what you see through your viewfinder. If you spend fifteen minutes composing an image, your chances of producing a good photograph are extremely high. There is literally a world of possible photo compositions; give yourself time to consider and evaluate some of the possibilities!

These two photos of a New York lake in autumn speak of the stillness left behind when summer ends. Notice how the empty picnic tables add to the visual story. In the horizontal photo, I used a large tree trunk as a border or frame for the right side of the image, and a spray of oak leaves at the upper left to add balance to the scene. In the vertical image, a few floating leaves in the foreground draw the viewer's attention and enhance the feeling of depth in the landscape. This exemplifies the way in which small elements of a photo composition can have a big impact on the overall impression the image gives.

Quick Tip

Once you have chosen a scene to photograph, slowly raise and lower your camera, pan left and right, and zoom to refine your composition.

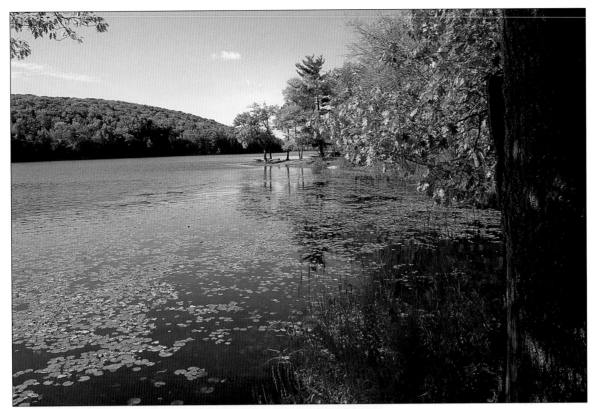

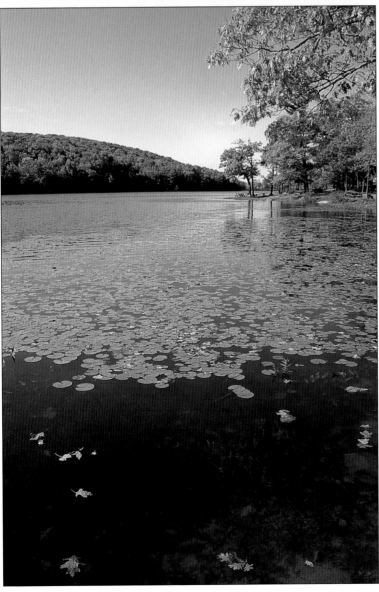

Sunrise Duet

Technical Specifications:

SETTING: Vulcan Lake, Kalmiopsis Wilderness, Siskiyou National Forest, Oregon, August morning

LENS: 28–200mm zoom set at 28mm

FILM: Fujichrome 100

EXPOSURE: $\frac{1}{60}$ second at f/8 (top), $\frac{1}{3}$ second at f/22 (bottom)

I took these two wide-angle images of a pristine lake in Oregon's Siskiyou Mountains. In the first photo (top), taken moments before sunrise, I placed the horizon low to emphasize the evergreen trees silhouetted against the sky. The feathery, high clouds add detail and visual appeal to the sky, while the tree reflections fill most of the lake.

Moments later I composed the second photo (bottom), just as the sun peeked over the horizon. This time I chose to place the horizon high in the image—approximately one-third of the way down from the top—to give greater emphasis to the reflections of the evergreens and clouds within the lake. A group of dark rocks that barely breaks the lake surface near the bottom of the photo strengthens the foreground. I stopped the lens down to f/22 to increase the depth of field so that both these foreground rocks and the background trees would be in sharp focus. For balance, I placed the sun off-center to the upper right in classic rule-of-thirds position, as discussed on page 28.

The second photo has an additional $1\frac{1}{2}$ stops of exposure compared to the first photo. This boost in exposure lightened the lake water, thus enhancing the level of contrast in the reflections.

Quick Tip

When photographing at a location on successive days, note the exact time and position of sunrise and sunset, then previsualize your images.

The winter greens of hemlock and rhododendron frame Dingmans Falls in Delaware Water Gap National Recreation Area, Pennsylvania, on a December day. To give waterfalls this cotton-candy look, use a long exposure such as ⅛ second, ¼ second, ½ second or even multiple seconds. (Medium-format camera with 135mm lens; Fujichrome 100 film)

Falling Water

PHOTOGRAPHING

WATERFALLS

Think Foreground

Technical Specifications:

SETTING: Dark Hollow Falls, Shenandoah National Park, Virginia, October afternoon

LENS: 28mm

FILM: Fujichrome 50

EXPOSURE: ½ second at f/16

I made these two wide-angle photos from slightly different locations at the base of Virginia's Dark Hollow Falls on an overcast afternoon. The featureless white sky was visually unappealing, so I composed these images with a minimum of sky to place maximum emphasis on the seventy-foot-high waterfall.

In photographing landscapes with wide-angle lenses, I always pay particular attention to the foreground of the scene. An empty or nondescript foreground, in which the lower part of the image is visually weak, often makes for a bland, flat-looking photo. In contrast, strong foreground objects, such as the lower falls in the horizontal photo or the wood and rocks in the vertical photo, significantly add to the visual appeal of the image. Prominent foreground objects also lend a sense of depth to landscape photos by providing visual "anchors" that help the viewer to better understand the perspective and to gauge distances and proportions.

For both of these exposures, the choice of a small aperture, f/16, ensured sufficient depth of field to get everything in focus from foreground to background, a fact confirmed by using my camera's depth-of-field preview feature. If your camera lacks this feature, you can use the depth-of-field scale that is marked on the top of some lenses for the same purpose. In the low light of this cloudy autumn afternoon, stopping the aperture down to

f/16 resulted in a long shutter speed of ½ second; this was sufficient to give the falling water a soft, cotton-candy appearance with pronounced vertical streaks in the water.

Quick Tip

Use depth-of-field preview to determine the front-to-back range of acceptably sharp focus that will appear in your landscape photos.

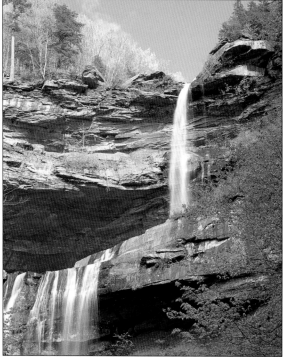

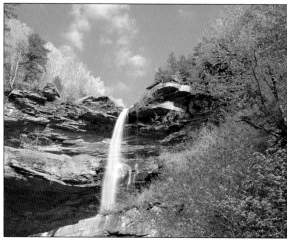

Progressive Realization

Technical Specifications:

SETTING: Kaaterskill Falls, Catskill Forest Preserve, New York, May afternoon

LENS: 45mm on medium-format (6x7cm) camera (top), 135mm on medium format (6x7cm) camera (bottom left and right)

FILM: Fujichrome Velvia 50

With a total drop of 260 feet, Kaaterskill Falls is one of the natural highlights of the Catskill Mountains, and is New York state's highest waterfall—yes, it is actually taller than Niagara Falls, though only a tiny fraction as wide! These three photos illustrate my approach to photographing the falls on a glorious spring day when the new leaves were unfurling and the forest was cloaked in a fresh coat of light green foliage. For each of the three exposures, I stopped down the lens to both maximize the depth of field and lengthen the exposure time for a silky rendition of the falls.

The first photo (top) is a wide-angle view, encompassing the natural amphitheater that forms the backdrop for the falls. The brightly sunlit falls are framed by foliage on either side and by the rocks below. A small patch of sunlit white water in the largely shady foreground serves as an important focal point that gives the image a far greater sense of depth. The falling water provides visual continuity; in essence, it pulls the image together from top to bottom.

The other two photos, taken from closer range with a short telephoto lens, are tighter portraits of the falls. The second photo (bottom left) is a strong vertical composition, with the water moving from upper right to lower left. In the third photo (bottom right), I framed the image horizontally to focus on the upper cascade and emphasize the detailed tex-ture of the foliage on the right. The horizon becomes a nice "V," which draws the viewer's vision to the top of the falls, and soft white clouds accent the sky.

Quick Tip

Consider the full range of compositional opportunities afforded by both wide-angle and telephoto lenses when you are photographing waterfalls.

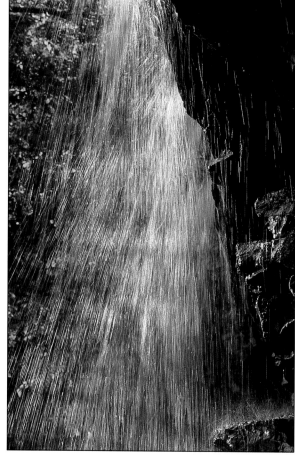

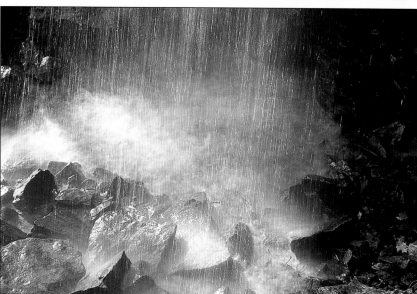

Side Lighting

Technical Specifications:

SETTING: Massanutten Mountain, George Washington National Forest, Virginia, November afternoon

LENS: 90mm

FILM: Fujichrome 50

EXPOSURE: $\frac{1}{30}$ second at f/8 (top left), $\frac{1}{15}$ second at f/8 (right), $\frac{1}{2}$ second at f/13 (bottom left)

Late on an autumn afternoon, I was attempting to coax interesting photos from a small, scraggly waterfall in Virginia's George Washington National Forest. The falls appeared through the viewfinder as a nearly transparent drip. The first photo (top left) shows the top of the falls as it appeared in a head-on view. The paltry amount of water, front lighting and light-toned sandstone combined for an uninteresting image of the waterfall. But photographically there are many alternative ways to render your subject on film. Your hardware choices—namely your selection of film, focal length, aperture, and shutter speed—always affect the photographic outcome. Beyond that, your software—the viewpoint you choose to photograph from and the way you ultimately compose the image in your viewfinder—will determine what you produce.

Quick Tip

Consciously look for dramatic lighting and find unique perspectives from which to compose your landscape photographs.

In this case, I walked beneath and to the right of the falls and looked up from close range into the spray of water coming over the rocks. The result is the second photo (right), a vertical composition enhanced by wonderful side lighting from the sun, which is out of the picture on the left side. The side lighting brings out a pronounced texture in both the falling water and in the rocks. I chose to include just enough of the wet rock face on the right to provide balance and give the viewer visual clues as to the context of the photo.

I moved to an even lower position to take the third photo (bottom left). In this composition, I isolated the base of the falls, again making use of natural side lighting to illuminate the water droplets streaking downward. Stopping the lens down to f/13 allowed me to use a $\frac{1}{2}$-second shutter speed, enough time to photographically record quite a bit of water falling into the image. Note that these three rather different images were all produced with a 90mm lens. With patience, persistence and a willingness to look for new viewpoints, you can often produce a variety of interesting compositions at the same focal length.

Crop with a Zoom Lens

Technical Specifications:

SETTING: North Falls, Silver Falls State Park, Oregon, February afternoon

LENS: 28–200mm zoom set at 40mm (top left), 28–200mm zoom set at 160mm (bottom left), 28–200mm zoom set at 200mm (right)

FILM: Agfa Scala 200x black & white slide film

EXPOSURE: 0.7 second at f/22 (top left), 1/30 second at f/5.6 (bottom left), 0.7 second at f/32 (right)

Zoom lenses are a wonderful convenience for nature photographers today. Most outdoor photo hobbyists can cover more than 90% of their desired lens needs by carrying two zoom lenses: a wide-angle to short-telephoto zoom, such as a 28–70mm, and a longer telephoto zoom, such as a 70–300mm. Another increasingly popular option is to use a single zoom lens extending from 28mm to 200mm or even to 300mm. The major improvement in optical quality of these extended-range zoom lenses, and their moderate prices, make a wider range of photos possible than ever before for most amateur photographers.

I took this trio of photos on a cloudy winter afternoon in Oregon's Silver Falls State Park. They illustrate the picture-framing possibilities of setting up your camera and tripod in one position and making use of the full zoom range of a 28–200mm lens. The first image (top left) gives a wide-angle overview of the site, including a little sky at the top, a border of Oregon grape at the bottom, and darker evergreens on each side to frame the distant waterfall. For the second photo (bottom left), I zoomed to 160mm, leaving only a few nearby branches on the left and upper right to frame the scene and impart a feeling of depth. Finally, in the third photo (right), I zoomed to 200mm, and used a vertical composition to put even greater emphasis on the falls. These three photos illustrate the importance of shutter speed selection; the first and third images were made with a 0.7-second shutter speed to accentuate the silky look of the falls. In the second image, I opened the lens to f/5.6 to make a shutter speed of 1/30 second possible. This much faster—though still rather slow—shutter speed gave the falls a markedly different, rougher texture.

Quick Tip

Make use of the full focal length range of your zoom lenses, and keep in mind that an intermediate setting is often your best choice.

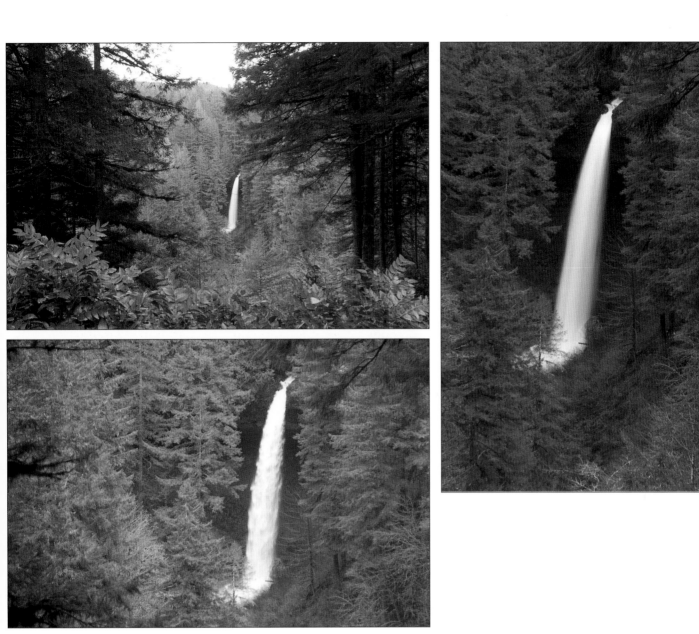

A Different Perspective

Technical Specifications:

SETTING: Ganoga Falls, Ricketts Glen State Park, Pennsylvania, October morning

LENS: 28–200mm set at 80mm (top), 17mm (bottom)

FILM: Fujichrome 100

EXPOSURE: $\frac{1}{3}$ second at f/27 (top), $\frac{1}{4}$ second at f/16 (bottom)

Waterfalls are frequently photographed head-on from vantage points directly in front of the falls, with the view extending for the full length of the falls. This often works well, but there certainly are other interesting ways to photograph waterfalls and their surroundings. Next time you are photographing a waterfall, be creative and find a different perspective! These two photos illustrate two alternative approaches to photographing a waterfall.

The first photo (top) shows an oblique perspective of Pennsylvania's Ganoga Falls, which drop 94 feet. I could not get a totally unobstructed view of the falls from this perspective, so I worked to compose an image that used other elements of the landscape in an advantageous way. This is a situation where a zoom lens is invaluable in allowing you to frame the view just as you like it. The result is that the waterfall is prominent, but is strongly complemented by the visual features that surround it—branches on top, a tree trunk and foliage at left, maple leaves on bottom and bare rock on the right. My selection of a shutter speed of $\frac{1}{3}$ second and aperture of f/27 for this exposure is beneficial in that the comparatively long exposure gives the falling water a smooth look, while the small aperture maximizes depth of field.

The second photo (bottom) shows one of the least appreciated and least photographed views around most waterfalls, namely the view from directly above the falls. A 17mm ultra-wide-angle lens takes in the riffles, rocks and fallen leaves above the falls. The abrupt drop-off at the top of the falls stands out against the sunlit autumn foliage in the background. I set up my tripod on the stream bank at the water's edge so as to place the viewer as far as possible into the scene. As a viewer, you cannot actually see the waterfall, but you know it is there.

If you attempt photography above a waterfall, keep your distance and be extremely cautious about your footing. Do not take chances; your life is worth more than a photograph.

Quick Tip

While composing photos, take time to consider all elements that will be visible in the image. Visually, everything in the composition matters!

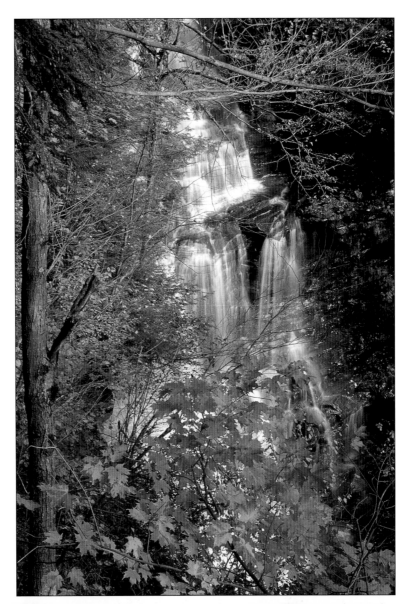

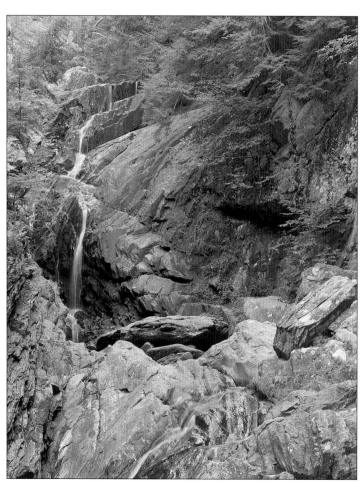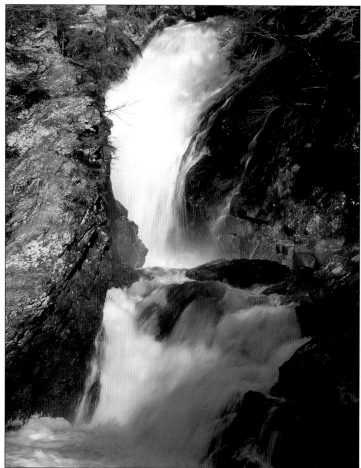

Technical Specifications:

SETTING: Campbell Falls, Berkshire County, Massachusetts, August afternoon and October midday

LENS: 135mm on medium-format (6x7cm) camera

FILM: Ektachrome 100 (left), Fujichrome 100 (right)

The one certainty in nature is change. Photographically, this is wonderful! The cycles of the days and seasons, the life cycles of plants and animals, the processes of ecological succession, the climatic cycles and the hydrologic cycle all add up to almost infinite visual variation for outdoor photographers to enjoy. Effectively putting these natural cycles on film—or at least recording representative stages of the cycles—can be a lifelong challenge for a nature photographer.

These two photos illustrate how dramatically watercourses may change over short time periods. I took the first photo (left) of Campbell Falls on the Massachusetts-Connecticut border on a cloudy August afternoon near the end of an unusually dry summer. The waterfall was reduced to a trickle, and resembled a small seep more than a waterfall. I photographed it anyway, since I had not visited the falls before, and wanted to produce a few "record" shots; that is, I simply wanted to make a photographic record of what the falls looked like on that day. I chose a short telephoto lens and set up in front of the base of the falls. I composed the image with the falls off-center on the left side, visually balanced by the foliage and rocks on the right side.

I went back to Campbell Falls two months later after a 3" rainfall during New England's wettest October of the 20th century. The falls was now a massive white torrent (right) that bore no resemblance to the trickle I had seen less than two months earlier. I used the same lens as on my August visit, and set up my tripod slightly further away from the falls, since the spot I had previously photographed from was now underwater.

I framed the scene to include both the top and the bottom of the falls. The lichen-speckled rock ledges on the left, brightly lit by the sun and brilliantly set off by the streaming white water, became a significant feature in the image. In contrast, most of the rocks on the right were in deep shade and thus seem to recede from the image compared to their appearance in the first photo.

Quick Tip

Choose several favorite nature scenes in your bioregion to rephotograph with similar compositions during each of the four seasons.

Falls in Shadow

Technical Specifications:

SETTING: Whiteoak Falls, Shenandoah National Park, Virginia, October afternoon

LENS: 28mm

FILM: Fujichrome 50

EXPOSURE: $1/30$ second at f/6.7

Like many outdoor photographers, I tend to focus much of my attention on photographing brightly lit subjects. For a refreshing change of pace, I enjoy creating compositions in which the main subject is not well lit compared to the remainder of the scene. While many waterfall photos feature well lit falls surrounded by darker vegetation or rocks, this pair of photos of Virginia's Whiteoak Falls reverses the usual relationship between subject and background.

Late on an autumn afternoon, the waterfall was in deep shade, but from my vantage point along the rim of Whiteoak Canyon, the nearby rocks and foliage were still in direct sunlight. I chose to take both a horizontal and a vertical composition, in each case putting significant care into arranging the composition to make best use of the features of the sunlit foreground to frame the falls. A 28mm lens provided a sufficiently wide angle of view to include some sky and two gracefully curving hemlock branches above the falls, brilliant red maple leaves to the right of the falls and nicely textured bedrock beneath the falls. The left side of the scene, especially in the horizontal composition, is deeply shaded forest, which shows no detail.

This was a difficult exposure situation due to the significant dark portions of the scene and the high contrast. If I had judged the exposure by metering the whole scene, the sunlit parts of the scene and the sky would have been grossly overexposed. Instead, I determined an appropriate exposure by taking a spot meter reading of the sunlit green foliage on the right side of the scene. This technique is frequently a good strategy to come up with a ballpark estimate of proper exposure in complex outdoor lighting situations. I then opened the aperture by $1/2$ stop to lighten the exposure and help bring out the deeply shaded waterfall in the image.

Quick Tip

For an interesting challenge, try to compose photos of waterfalls that are in shade and are substantially darker than their surroundings.

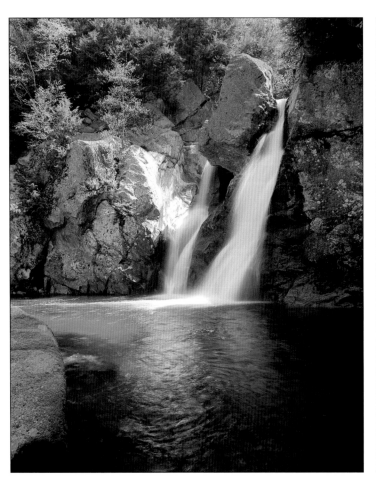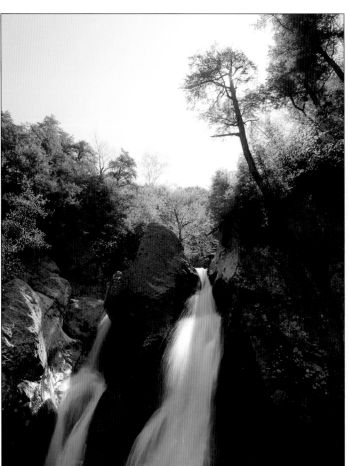

Spring Morning

Technical Specifications:

SETTING: Bash Bish Falls, Mount Washington State Forest, Massachusetts, May morning

LENS: 45mm on medium-format (6x7cm) camera

FILM: Fujichrome Velvia (ISO 50)

EXPOSURE: ⅛ second at f/19 (left), ½ second at f/22 (right)

Spring mornings are superb for nature and landscape photography. The new coat of foliage on broad-leaved trees has a special vibrancy and a colorful palette of light-to-medium greens that is found only during this season. Add to that the runoff from spring showers and you have a recipe for spending glorious hours photographing running and falling water.

The left photo shows the twin cascades of southwestern Massachusetts' Bash Bish Falls viewed from the edge of the green pool at the base of the falls. I chose a very low vantage point to accentuate the height of the falls. A wide-angle lens allowed me to include much of the green pool, the falls and a small patch of the forest above and to the left of the falls. The boulder at the lower left of the image provides a visual anchor, giving the viewer a feeling for the depth of the scene and for the scale of other features in the image. I stopped down the lens to f/22 to maximize depth of field while also maximizing the length of the exposure to soften the falls.

The right photo is a strikingly different, semi-silhouetted view of the falls and its surroundings that I took from a nearby position to the left of where I took the first photo. I chose to compose the image with a substantial amount of sky to emphasize the area above the falls; notice how several backlit trees stand out. Other light-toned focal points are the sunlit part of the right cascade and the area near the lower left where sunlight is reflected off shiny, wet rock. I arrived at the exposure by metering the full scene and adding one stop to partially compensate for the bright sky and sun. Even with this compensation, this exposure, ⅛ second at f/19, is still 1½ stops darker than the exposure of the top photo, ½ second at f/22, hence the silhouetted appearance.

Quick Tip

In difficult exposure situations, write down your exposures, then review your photos with your field notes to learn what worked.

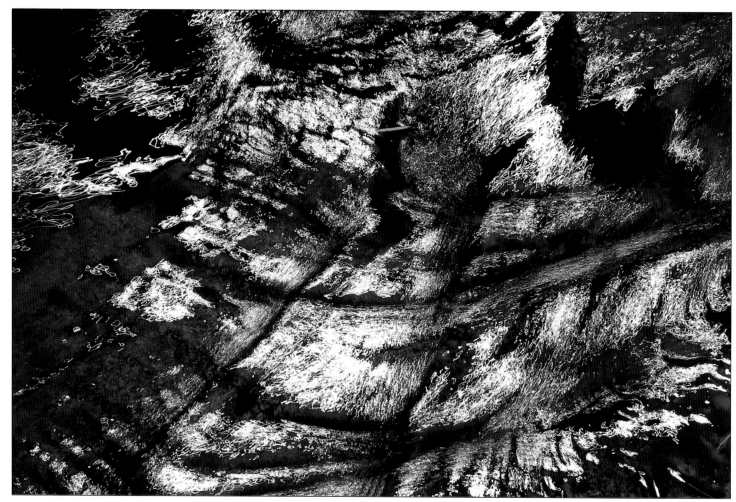

Direct sunlight reflected by the turbulent water of Drift Creek in Oregon's Siuslaw National Forest produced a maze of hydroglyphics as described in this chapter. I overexposed the image by a full stop compared to my meter reading to compensate for the brightness of the scene. (28–200mm zoom lens set at 200mm; Fujichrome 100 film; ¼ second at f/27)

Magical Water

PHOTOGRAPHING
WATER ABSTRACTS
AND REFLECTIONS

Liquid Stone

Technical Specifications:

SETTING: Crum Elbow Creek, Vanderbilt Mansion National Historic Site, Hyde Park, New York, August afternoon

LENS: 75–300mm zoom set at 300mm

FILM: Fujichrome 100

EXPOSURE: ½ second at f/27

This image illustrates the photographic magic possible where white water, rocks, direct sunlight and shadows come together. The water in this sprightly little Hudson Valley creek, brightly lit by the summer sun, alternated between smooth and turbulent flow. I cropped the scene as tightly as I could by setting up my tripod very low, moving in close, and using a long focal length, 300 mm, to create a strong composition.

This is a situation where your camera's exposure meter, which is calibrated for a medium-toned scene, is apt to be fooled and produce an underexposed photo. In reality the scene was very light in tone, considering both the white water in the left half of the photo and the bright highlights of sunlight reflecting off the glassy water surface on the right. I chose to overexpose by one stop compared to the camera's meter reading and thus lighten the scene.

Choosing a slow shutter speed is critical to get the effect you see in this photo. Given the reciprocity between shutter speed and aperture, I could have chosen combinations ranging from ¹⁄₄₅ second at f/5.6 (with the lens wide open), to ⅛ second at f/13, to ½ second at f/27 (with the lens stopped down all the way). I chose to use ½ second at f/27 because the small aperture maximized the depth of field and, more importantly in this situation,

the shutter was open for a longer time to smooth the motion of the water on the right and accentuate the sunlight sparkling on the water on the left.

Quick Tip

Use longer telephoto lenses to isolate small portions of rivers and streams that have strong visual appeal.

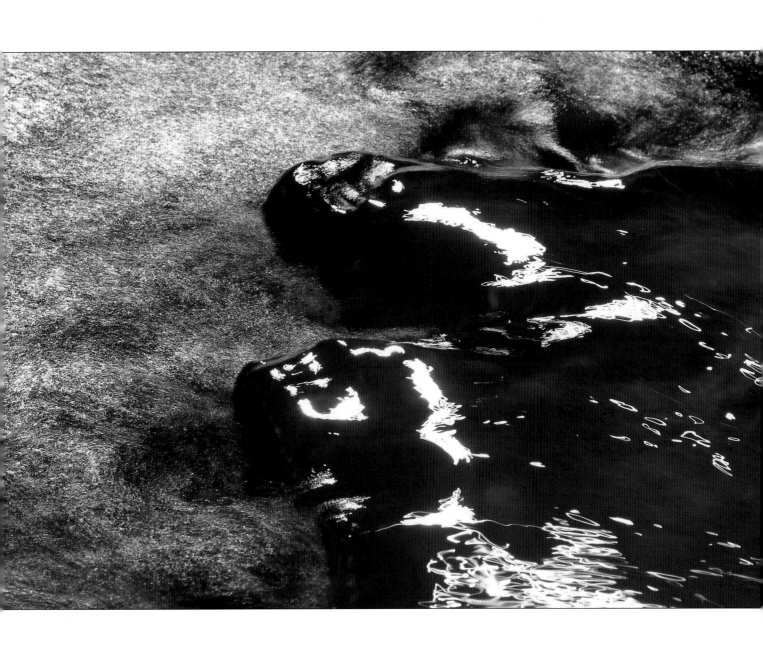

Fusion of Rock and Water

Technical Specifications:

SETTING: Glacier Creek, Rocky Mountain National Park, Colorado, July morning

LENS: 70–210mm zoom

FILM: Kodachrome 25

EXPOSURE: 8 seconds at f/22

This image is abstract in the sense that there are no strong clues as to the size of the solid rock in the photograph. I have been asked several times whether this is a photo of clouds swirling around a mountain with a bare rock surface. In reality, you are looking at a small boulder protruding approximately two feet above the surface of a swift, turbulent Rocky Mountain stream that is enlarged by glacial meltwater during the summer.

My goal was to produce a photo that somehow captured the eternal interaction between rock and running water, and suggested how moving water ultimately shapes hard rock. Three factors—low light levels in a shady forest, very slow film (ISO 25) and a small aperture (f/22)—combined to create a situation where it was possible to use a long exposure of eight seconds. Keeping the shutter open for such a long time meant that the film recorded a composite of all of the motion that occurred in the water during that eight-second period. The result is an image in which the water surface is softened and smoothed. The powerful, erosive force of the water pounding against, and ultimately shaping, the boulder was reproduced on film as a mist that seems to embrace the rock.

This is a very simple composition, something of a visual balancing act between hard, dark rock and soft, light water. The very light tones to the immediate left of the rock and in back of the rock on the upper right help make the rock stand out in the image. The left side of the rock is lightened by the reflection of sunlit green foliage on trees next to the creek. Notice also how the rock is off center in the image; simply moving the main point of interest away from the center of a photographic composition often makes for a more intriguing image.

Quick Tip

By choosing to photograph in low light with slow films, you will often have the option of taking long exposures of multiple seconds.

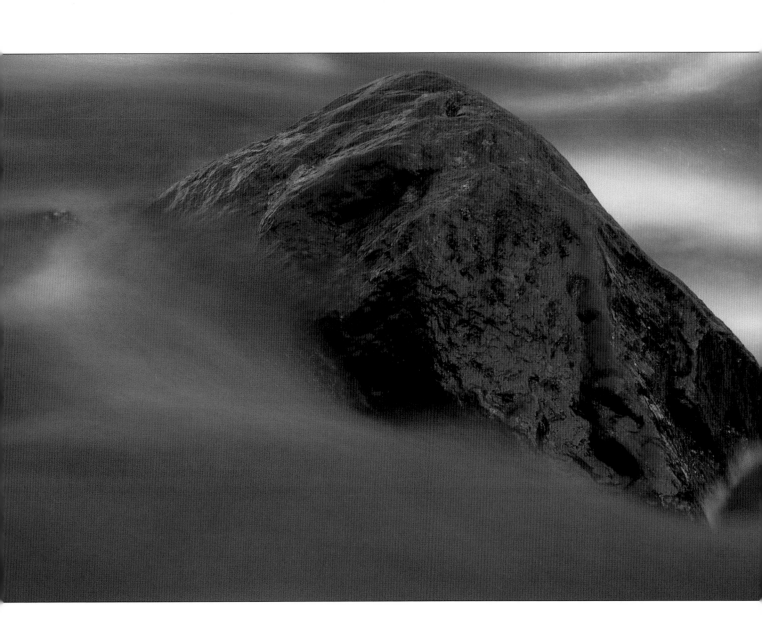

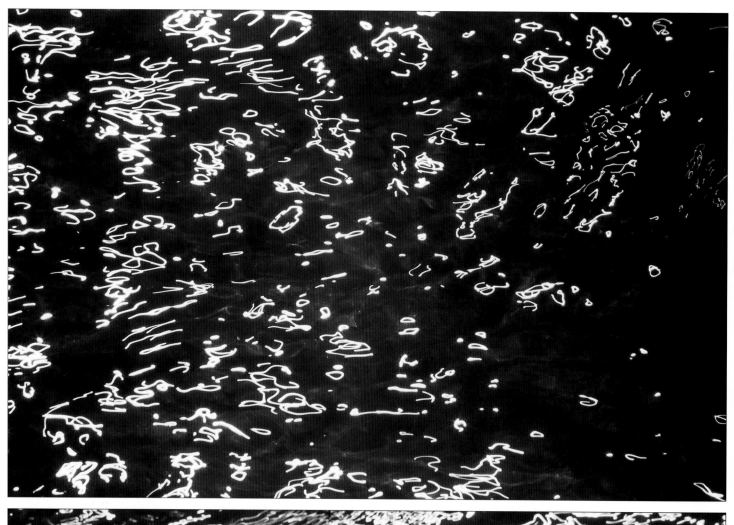
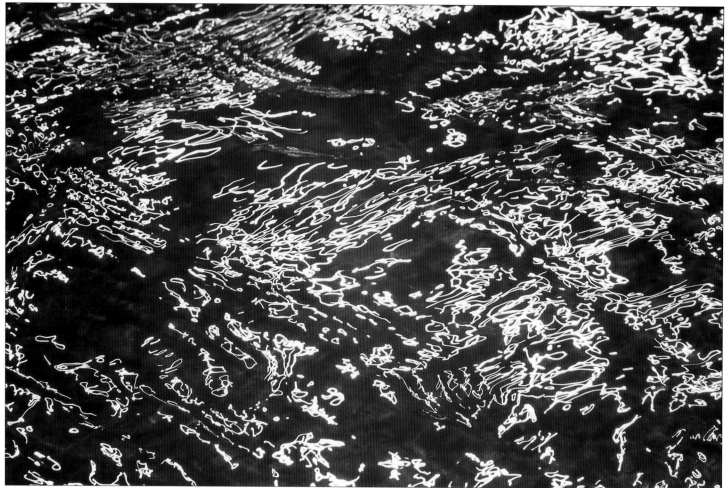

Technical Specifications:

SETTING: Oconaluftee River, Great Smoky Mountains National Park, North Carolina, March afternoon

LENS: 75–300mm zoom set at 300mm

FILM: Fujichrome 100

EXPOSURE: $\frac{1}{45}$ second at f/27 (top), $\frac{1}{20}$ second at f/27 (bottom)

Acclaimed nature photographer David Cavagnaro uses the term *hieroglyphics* to refer to the way that long exposures of sunlight sparkling on moving water produce indecipherable scrawls of silver or golden light on the water's surface. Given the subject matter, *hydroglyphics* might be an even more apt name for this photographic phenomenon. Inspired by viewing some of Cavagnaro's superb images more than a decade ago, I have enjoyed many sunny days photographing streams and rivers while refining techniques for producing better photos of hydroglyphics.

One of the joys of photographing hydroglyphics is that each photo is unique. Just as it is said that no two snowflakes are ever perfectly identical, no two hydroglyphic images are ever exactly the same. Even the tiniest shift in the position of the sun, the motion of the water or the camera angle will produce a somewhat different image, and altering the shutter speed will significantly change the photograph. Lengthening the shutter speed by one stop, say from $\frac{1}{8}$ second to $\frac{1}{4}$ second, gives the sunlight time to "write" twice as much on the water during the exposure.

I took these two abstract images a few minutes apart; they show two different close-up views of a shallow, fast-running river in bright sunlight. In both cases, I focused on the water surface, and I stopped the lens down fully to f/27 to maximize depth of field and allow for the longest shutter speed possible given the conditions. The second photo (bottom) shows an area with more sun sparkles on the surface. This image was made with a shutter speed approximately twice as long as the first photo (top), thus producing a denser, more complex pattern of hydroglyphics.

I purposely overexposed both images by one stop compared to my camera's exposure meter reading. For example, my metered exposure for the first photo was $\frac{1}{90}$ second at f/27, but I used a shutter speed of $\frac{1}{45}$ second, which is twice as long. The longer exposure compensated for the fact that the sunlight reflected by the water surface was much brighter than the middle gray tone for which exposure meters are calibrated.

Quick Tip

Unlike many outdoor photo subjects, hydroglyphics can easily be photographed well at midday in the summer when the sun is at its highest point.

More Hydroglyphics

Technical Specifications:

SETTING: Oconaluftee River, Great Smoky Mountains National Park, North Carolina, June morning

LENS: 28–200mm zoom lens set at 135mm

FILM: Ektachrome 100

EXPOSURE: $\frac{1}{30}$ second at f/5.6 (left), 1.5 seconds at f/32 (right)

This second pair of hydroglyphic images highlights the creative possibilities inherent in bracketing exposures once you have composed a close-up portrait of sun sparkling on the surface of rapidly moving water. Bracketing refers to making two or more photos of the same composition with slightly different exposure settings. The first exposure (left) was taken with the lens aperture opened up to f/5.6. The resulting shutter speed of $\frac{1}{30}$ second is long enough to register complex scrawls of light bouncing off the moving water, but this shutter speed is short enough to still leave many noticeably dark areas between the scrawls. Aesthetically, these areas serve as negative space between the bright hydroglyphics.

The second image (right) was taken moments after the first, without moving the camera and tripod. This time I stopped the lens down to f/32, lengthening the exposure to 1.5 seconds. This exposure was thus forty-five times as long as the first exposure. As a result of this much longer shutter speed, the hydroglyphics were reproduced on film like a thicker white mat on the surface of the water, giving this image an altogether different feel than the first exposure.

Since I took these images with the camera pointing virtually perpendicular to the river's surface, there is no externally defined top and bottom to the composition. In such situations, I take time to move the camera around—sometimes a full 360°—to find what I consider the most appealing composition. In this particular case, I moved the camera until I was satisfied with the strong diagonal lines as well as the positioning and balance of prominent light and dark areas in the composition.

As in the previous hydroglyphic example, due to the extraordinary lightness of the scene—the images consist largely of summer sunlight bouncing off the water's surface toward my camera—I intentionally overexposed both images by one stop compared to my exposure meter reading. Without this compensation, which doubled the amount of light reaching the film, the photos would appear much darker.

Quick Tip

If you are unsure of the ideal exposure setting, take two or three exposures and make minor changes in aperture or shutter speed.

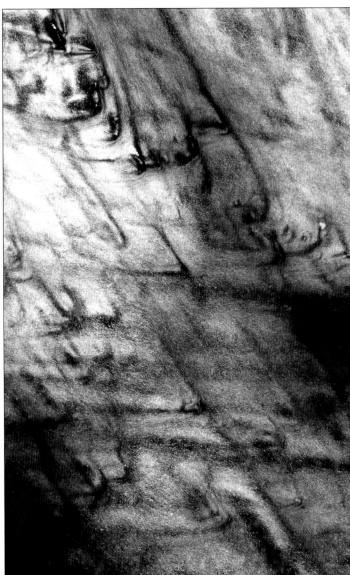

Studies in Reflection

Technical Specifications:

SETTING: Fowler Lake, Ridgefield National Wildlife Refuge, Washington, February afternoon

LENS: 75–300mm zoom set at 130mm (top and center), 75–300mm zoom set at 300mm (bottom)

FILM: Fujichrome 100

EXPOSURE: $\frac{1}{30}$ second at f/9.5 (top and center), $\frac{1}{30}$ second at f/8 (bottom)

When you find aesthetically pleasing reflections in the field, the challenge is to determine how to compose photographs that communicate to the viewer the same beauty that you see. This trio of photos offers three visions of a Pacific Northwest lake in winter. I was drawn to the fine detail in the multitude of tree branches mirrored in the lake's surface.

The position in which you place the shoreline is a key factor in determining the impression created by a reflection photo. I composed the first photo (top) with the lakeshore just below the middle of the image. To compose the second image (center), I did not move my tripod, but simply tilted the camera downward. The shoreline was now positioned approximately one-third of the way down from the top of the photo. This put much greater emphasis on the reflection.

Quick Tip

When you are photographing reflections in a pond or lake, try moving the shoreline higher and lower for variety in your compositions.

To create the third image (bottom) a few minutes later, I zoomed to a much longer focal length. At 300mm I was able to isolate a piece of the upper right portion of the second photo, and I placed the shoreline very close to the top of the photo. This reflection has a very different feel to it. The foreground is quite blurred and abstract as a consequence of both the reduced depth of field at this much longer focal length and the magnification of the wind-driven rippling of the lake's surface.

You might as well have some fun before turning the page, so go ahead and turn the book upside-down to enjoy these reflections inverted!

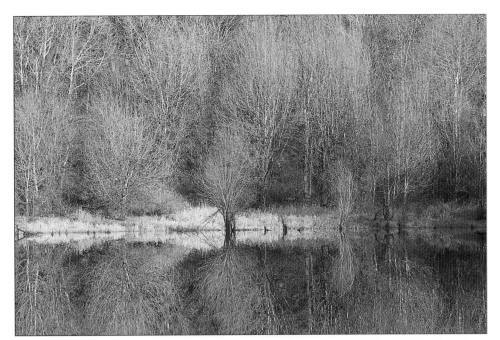

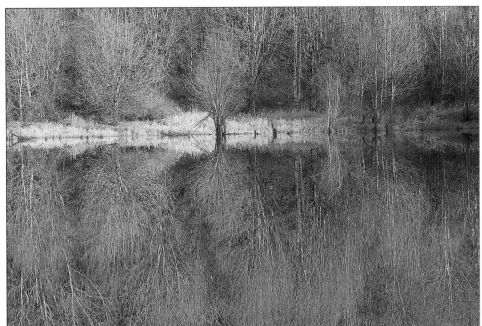

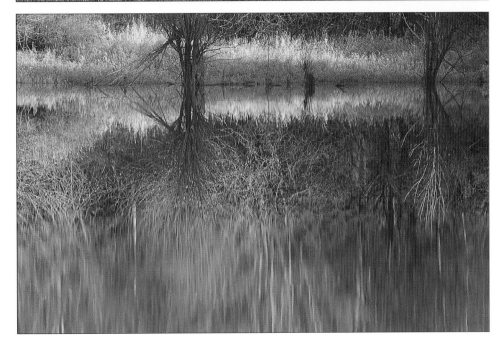

Shadow Play

Technical Specifications:

SETTING: Chasteen Creek, Great Smoky Mountains National Park, North Carolina, May afternoon

LENS: 135mm on medium-format (6x7cm) camera

FILM: Ektachrome 100

EXPOSURE: ¼ second at f/16

During a spring hike near Smokemont in the Great Smoky Mountains, my eye was captured by this interesting shadow of a rhododendron shrub on the white water of a lively mountain stream. While standing on a small bridge over the creek, I set up my camera and tripod with a short telephoto lens aimed downward toward the water. The result is an engaging study in light and dark. What you see are the shadows of rhododendron leaves separated by areas of white water illuminated by intense sunlight.

I stopped down the lens to f/16 to ensure adequate depth of field for a sharp image from top to bottom. Given the reciprocity between aperture and shutter speed, this choice of a small aperture also made it possible to use a ¼-second exposure. This is a long enough exposure to record a lot of motion in the sun sparkles on the surface of the rapidly moving water. Because of the overpowering brightness of the sunlit portions of this image, particularly the upper left section, I intentionally overexposed the image by one stop compared to my metered exposure reading. The exposure meter indicated ⅛ second at f/16 as the correct exposure, so to overexpose by one stop I used a shutter speed twice as long, ¼ second at f/16.

Quick Tip

Make use of shadows on white water to create unusual photographic compositions.

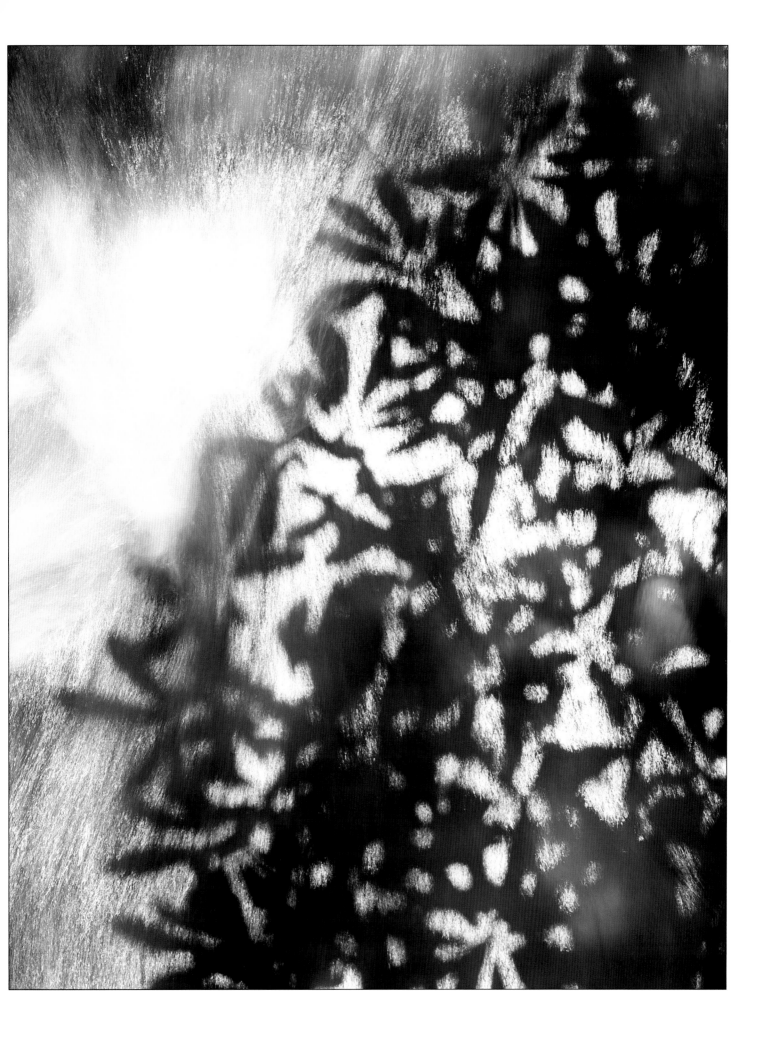

Stained Glass

Technical Specifications:

SETTING: Dawson Creek, Hillsboro, Oregon, February afternoon

LENS: 28–200mm zoom set at 28mm

FILM: Fujichrome 100

EXPOSURE: 1/15 second at f/4.5

The bare branches of deciduous trees are a classic subject in the genre of reflection photography. There is something wonderfully elemental about the starkness of these living skeletons of the North American winter.

I photographed this reflection in the low light of late afternoon on a partly cloudy winter day. The 28mm focal length gave a wide enough angle of view to include a suitable amount of the reflection in this photo. The white clouds mottling the blue sky made a nice background for the naked branches in the reflection. A slight breeze rippled the water, so I chose to shoot with the lens aperture opened wide to f/4.5 to give a shutter speed of 1/15 second. This shutter speed, while relatively slow, was just fast enough to reproduce some of the reflections of feathery branches sharply. Other parts of the image have a slightly distorted, rippled appearance, reminiscent of stained glass. If I had used a slower shutter speed, the image would have been noticeably blurrier.

Quick Tip

Your selection of shutter speeds is a key determinant of how moving water will appear in your photos.

Notice the visual appeal of the many strong diagonal lines in this composition. Diagonal lines have a sense of instability or dynamism about them; our understanding of gravity, first gained in early childhood, tells us that objects can remain stationary in a vertical or a horizontal position, but usually not in a diagonal position. Thus diagonal lines, more so than horizontal or vertical lines, have an inherent tendency to enliven a photograph.

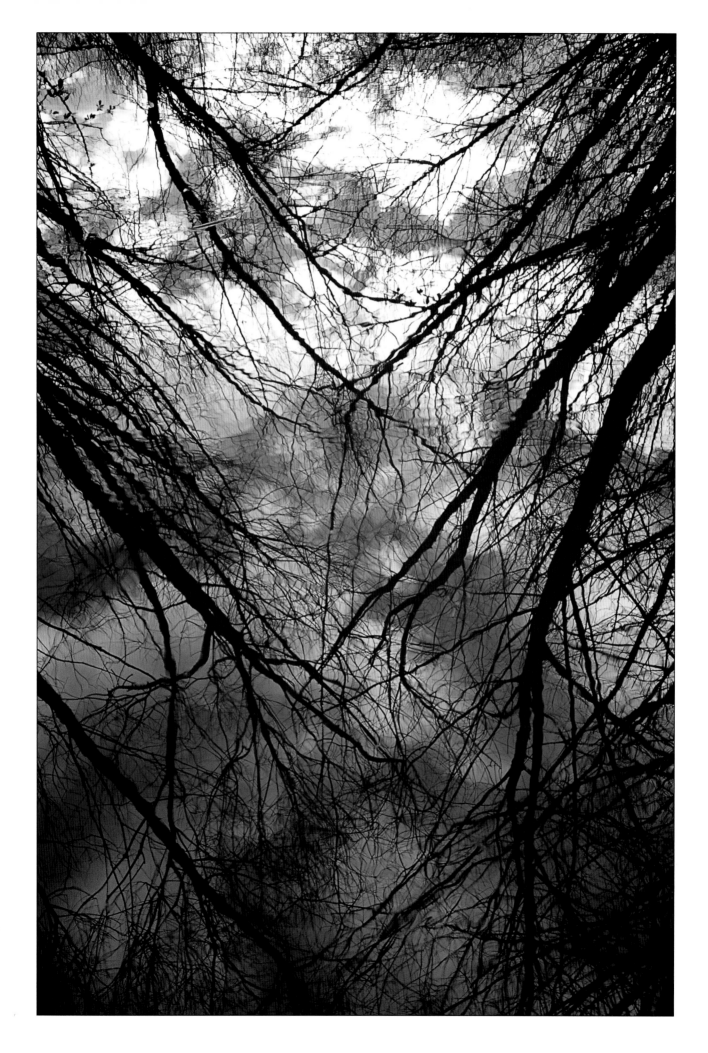

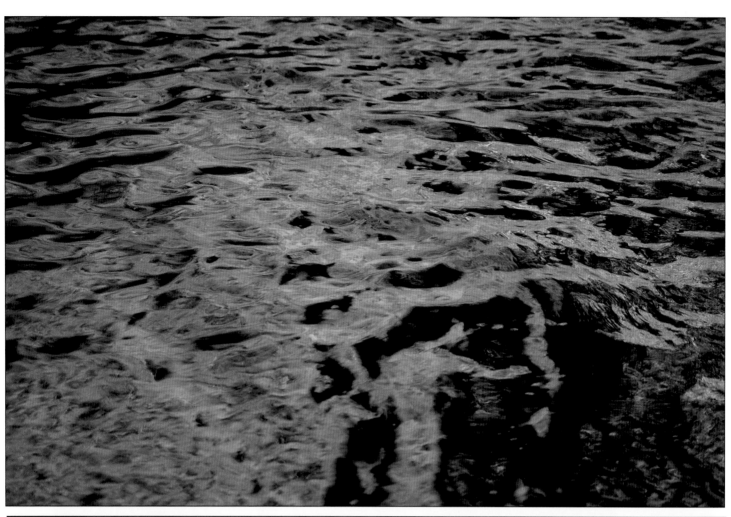
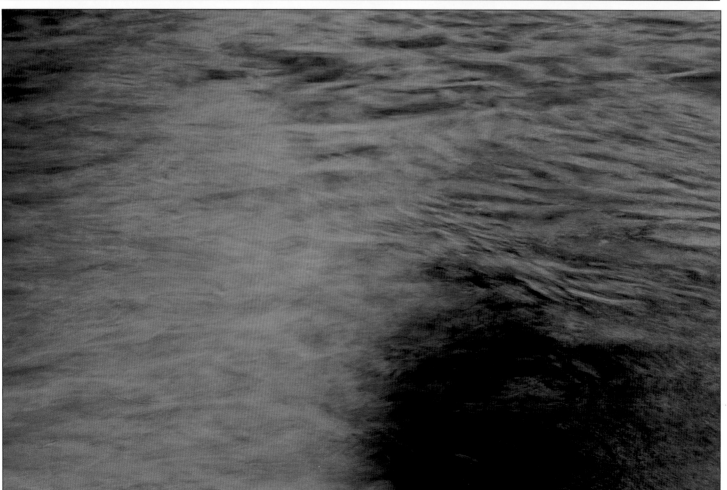

Shutter Speed Comparison

Technical Specifications:

SETTING: Dingmans Creek, Delaware Water Gap National Recreation Area, Pennsylvania, August afternoon

LENS: 75–300mm zoom set at 300mm

FILM: Fujichrome 100

EXPOSURE: $^1/_{30}$ second at f/5.6 (top), 0.7 second at f/27 (bottom)

These two images—framed identically and taken one after the other—illustrate the powerful effect that choice of shutter speed has on the appearance of photos of moving water. They also exemplify some of the compromises inherent in nature photography. With my camera and tripod set up on the creek bank, I zoomed in as much as possible on the stream with a 75–300mm lens to compose the reflections of the green forest as tightly as possible. The reach of the 300mm focal length allowed me to keep out extraneous objects such as the creek bank and some low-hanging branches.

The shutter speed of $^1/_{30}$ second in the first image (top) is not fast enough to fully "freeze" all the ripples on the water, but nonetheless many of the ripples are defined well enough to give a strong sense of the uneven surface of the water, and to provide an interesting texture. It would likely take a shutter speed of $^1/_{125}$ second or faster to completely stop the motion. In this situation that would have either required film that was two stops faster (ISO 400) than the ISO 100 film I used, or a telephoto lens with a maximum aperture that was two stops faster (f/2.8) than the f/5.6 lens I used.

The second image (bottom) was taken at the other extreme of aperture and thus a much slower shutter speed. With the lens stopped down to a tiny f/27, the shutter had to remain open 0.7 second to expose the film to enough light. Photographically, this is quite a long exposure of moving water. This resulted in a smoothing of the ripples, a significant loss of detail, and a softer texture because the ripples moved significantly during the time the shutter was open.

Quick Tip

By writing down your exposures, you will learn from experience what shutter speed is sufficient to freeze motion in various situations.

Sky in the Lake

Technical Specifications:

SETTING: Fernhill Lake, Forest Grove, Oregon, January sunset

LENS: 28–200mm zoom set at 28mm (top left and right), 28–200mm zoom set at 70mm (bottom left)

FILM: Fujichrome 100

EXPOSURE: $1/125$ second at f/8 (top left), $1/125$ second at f/5.6 (right), $1/125$ second at f/4.5 (bottom left)

The half hour just before sunrise and just after sunset are frequently the most magical times of day for nature and landscape photographers. A wonderful range of warm and cool colors combine with dramatic lighting, good reflections and strong silhouettes to create eye-catching scenes. The ephemeral nature of these magical times—blink (or oversleep!) and the great light is gone—makes putting them on film all the more challenging.

I took these three photos soon after the sun disappeared into the clouds along the western horizon at the end of a winter day. In such a photogenic big-sky, big-water situation, I usually opt for a wide-angle focal length, 28mm in this case, to capture the most expansive view. As the light changes I photograph at least several different compositions, always cognizant of the balance between sky and water in the scene. Notice how the vertical composition of the second photo (right) allowed me to include more of both the clouds and the reflection in the lake than the horizontal composition of the first photo. In the third photo (bottom left), I zoomed to 70mm for a portrait of a portion of the reflection in the lake.

When you are photographing in this magical light at either end of the day, keep in mind that the ambient light—and thus the correct exposure—usually changes rapidly. Though these three exposures were taken in succession, I used a different exposure setting for each one. I opened the lens aperture to compensate for the fading light, going from f/8 for the first to f/5.6 for the second, then to f/4.5.

Quick Tip

When light levels are changing rapidly, check your exposure meter and make needed adjustments immediately before taking each photo.

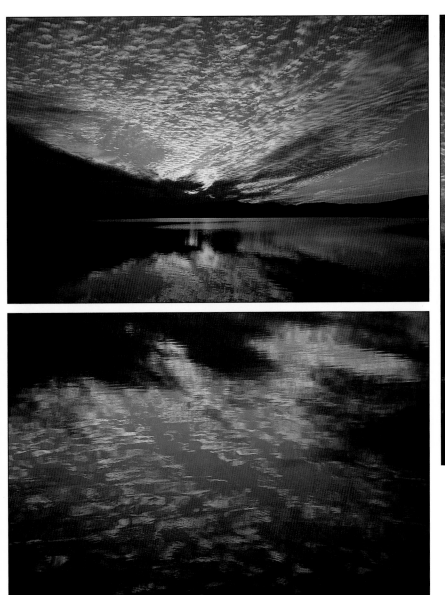
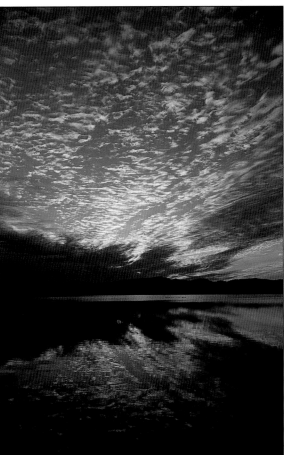

Up Close and Simple

Technical Specifications:

SETTING: Coxing Kill, Minnewaska State Park, New York, December afternoon

LENS: 135mm on medium-format (6x7cm) camera

FILM: Fujichrome Velvia (ISO 50)

EXPOSURE: ½ second at f/32

These three images were the product of an afternoon photographic ramble through the forest on a partly sunny winter day in New York's Shawangunk Mountains. The Hudson Valley's Dutch settlers christened many places with the name "kill," meaning creek or stream in their native tongue. Coxing Kill is a beautiful, shallow stream that flows over many bare rock shelves as it winds through a forest of maple, beech, birch and hemlock.

The setup was similar for each of these photos; I positioned my camera and tripod on a tiny bedrock island in the midst of the creek, and faced upstream in the direction of the winter sun. My attention was drawn to sunlit white-water riffles. Turbulent water can appear chaotic; my photographic objective here was to simplify and find order in the rushing stream. I used a "subtractive" approach to compose these photos; that is, I moved closer and refined each composition with my short telephoto lens until I felt there was nothing left that I could remove from the image.

Quick Tip

The phrase "add light to light" is a good reminder to intentionally overexpose light-toned scenes to yield true-to-life exposures.

In each case I stopped the lens down to f/32 and intentionally overexposed the photo by one stop relative to the metered exposure of ¼ second by doubling the length of the shutter speed to ½ second. This compensated for the very light tone of the direct sunlight on the water.

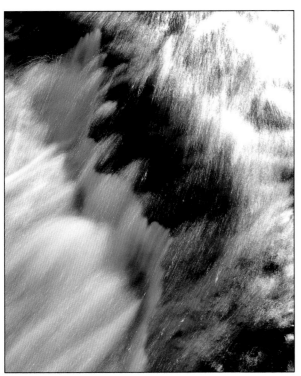

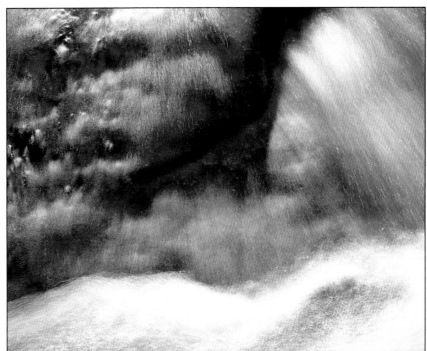

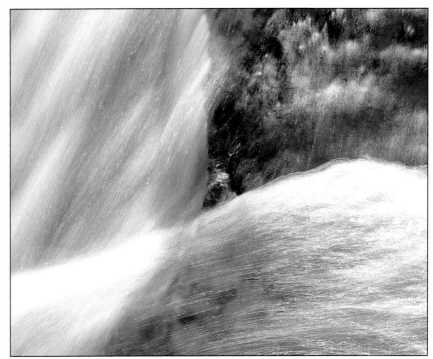

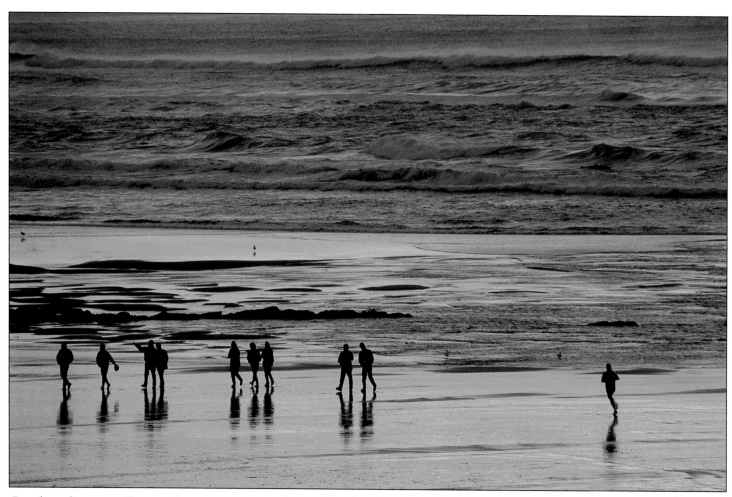

Beachcombers are silhouetted at sunset on an Oregon beach. The day's last rays of sun lit the spray on top of the breaking waves in this simple composition. (75–300mm zoom lens; Fujichrome 100 film)

Salt Water

PHOTOGRAPHING

AT THE

SEASHORE

Catch the Waves

Technical Specifications:

SETTING: Cape Perpetua Scenic Area, Siuslaw National Forest, Oregon, July afternoon

LENS: 28–200mm zoom set at 28mm (top and bottom left), 35mm (bottom right)

FILM: Fujichrome 100

EXPOSURE: $1/30$ second at f/22 (top), $1/45$ at f/22 (bottom left), $1/90$ second at f/11 (bottom right)

The wild, relentless energy of ocean waves exploding against a rocky coastline has few parallels in nature, and the Pacific surf, in particular, coming into contact with the mass of the North American continent has stunning visual power. This series of three wide-angle images illustrates techniques for putting this dynamic force on film.

Given the prominence of the water motion in photos of waves striking land, your choice of shutter speed goes a long way toward determining how your images will appear. The first photo (top) is a horizontal composition made with a comparatively slow $1/30$-second shutter speed, which recorded a lot of motion of the surf spray. For the second (bottom left) and third (bottom right) photos, both vertical compositions, I used faster shutter speeds. Notice how a $1/45$-second exposure for the second image still picked up significant water motion, though not as much as in the first photo. The $1/90$-second shutter speed of the third photo is only one third as long as the first exposure. As expected, much less motion is visible in the surf spray; in fact, much of the water appears frozen in place.

Notice how each of the three compositions has its own strengths. The first photo shows a wider horizontal expanse than the other two, including the ocean on the left. The second image places more emphasis on the tide pools in the foreground through use of a vertical composition and much higher placement of the horizon. And the third photo combines tide pools in the foreground with a clearer view of the cloud-topped headland in the background, and includes more sky above the headland than the other two.

Quick Tip

Wide-angle lenses provide abundant depth of field, giving you freedom to select an exposure based mainly on shutter speed considerations.

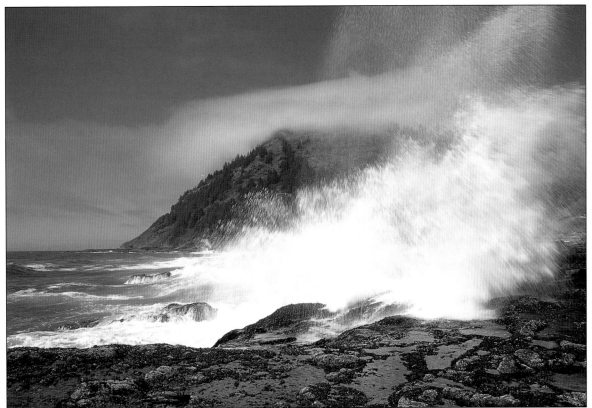

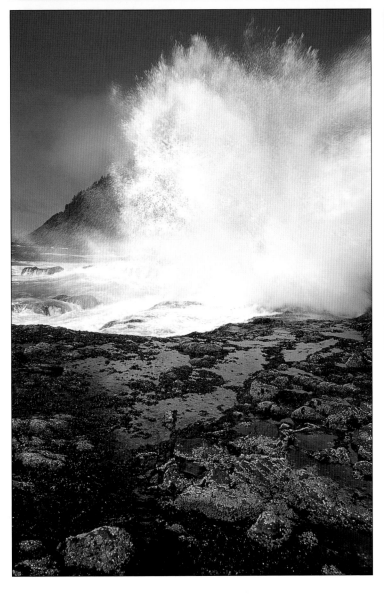

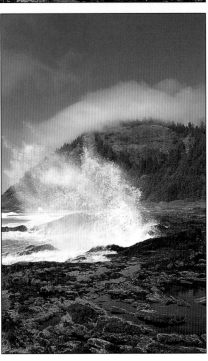

Sunset on the Beach

Technical Specifications:

SETTING: Roads End State Wayside, Lincoln City, Oregon, January sunset

LENS: 75–300mm zoom set at 300mm

FILM: Fujichrome 100

Some of the best sunset photos do not even show the sun. I took these two images from a coastal bluff only minutes before sunset. The dramatic, warm backlighting of the setting sun gives these two images their character and power, even though the sky and sun are not included in either image. Instead, the focus is on the beach, where land and water meet.

The image of the jogger (top) is an example of what is sometimes termed a "decisive moment" photo, freezing the runner's motion as she crosses the brightest sunlit swath of beach. From experience I have learned that a shutter speed of $\frac{1}{125}$ second or faster is generally needed to freeze motion of this sort. The jogger stands out in silhouette against the

Quick Tip

To make full use of the wonderful light of the setting sun in your photos, arrive at your field site at least an hour prior to sunset.

gleaming, wet sand. I zoomed to 300mm to make her as prominent as possible from my vantage point. The surf gives the upper half of the photo a darker, textured background contrasting with the lighter, smooth beach in the foreground.

The other photo (bottom), taken soon after the jogger had moved out of the scene, puts full emphasis on the beach itself. Here, without a dominant point of interest in the photo, I chose a vertical composition to emphasize the interesting diagonal lines and geometric patterns left behind by the ebbing tide on the wet sand surface. I positioned the bright vertical swath of reflected sunlight off-center to the left to provide a better balance between light and dark, and I relegated the surf to the very top portion of the image.

Producing photos like these two is a matter of putting yourself in the right place at the right time. The keys are to scout out good viewpoints in advance, to know when and where the sun will set, to watch the tides and weather, and to be there ready to photograph when the light is right.

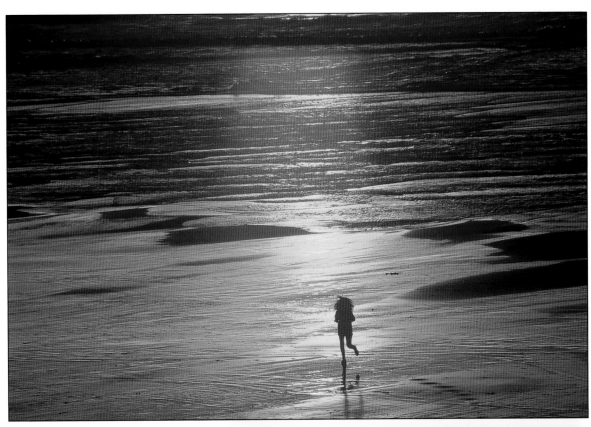
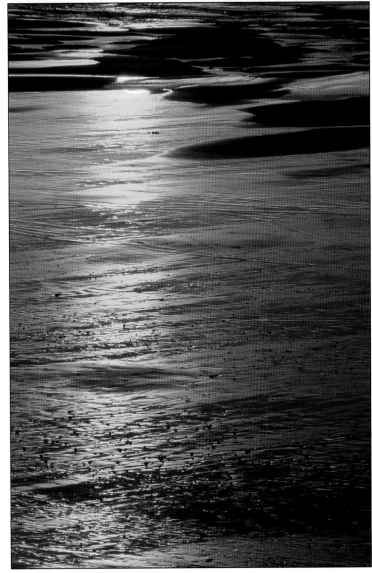

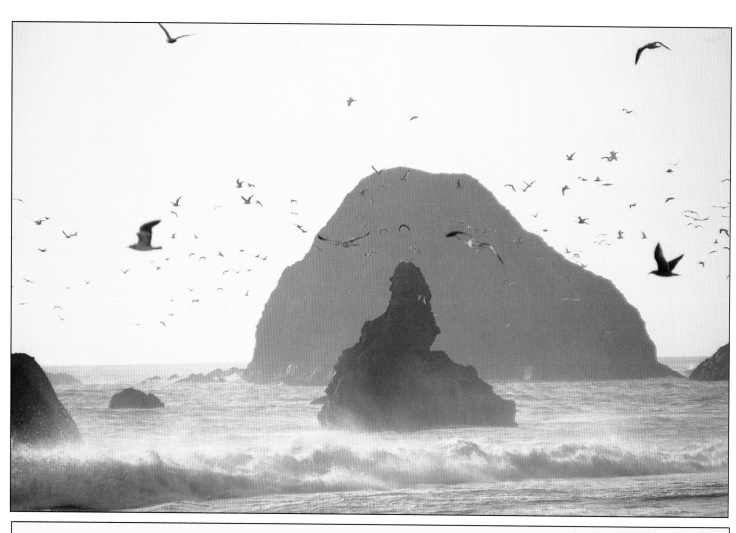

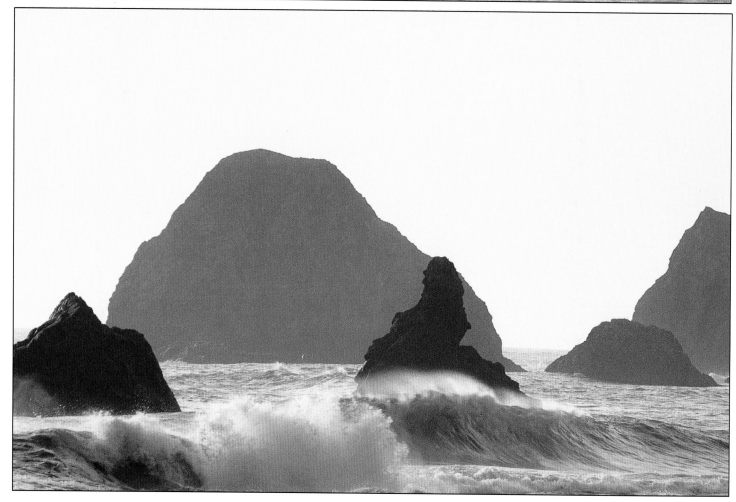

Technical Specifications:

SETTING: Sonoma Coast State Beach, Jenner, California, March afternoon

LENS: 180mm with 2X teleconverter = 360mm

FILM: Fujichrome Velvia pushed one stop to ISO 100 (top), Kodachrome 200 pushed 1⅓ stops to ISO 500 (bottom)

These two images exemplify one of the great joys known to landscape and nature photographers; namely that the world is always changing. Light levels shift by the minute and the hour, animals move in and out of a scene, waves form and break, and the tides ebb and flow. The intrepid outdoor photographer is often rewarded for staying with a subject and photographing the inevitable but often unpredictable changes that come with the passage of time.

The first photo (top) shows a lively sky full of gulls. While photographing wildlife, I sometimes wait hours for the perfect composition of animals and landscape. In this case, with my camera on the tripod, I composed the seascape, then waited only seconds before pushing the cable release as masses of birds swirled through the scene. The situation was in a way analogous to street photography, where you catch sight of some visually striking human drama as it happens, you compose rapidly and take your best shot.

I took the second photo (bottom) later in the afternoon from another position further to the left. Notice how this altered the alignment of the offshore rocks. Unlike the first image, no gulls are in the air, but birds atop a couple of the rocks are silhouetted against the sky to add a nice accent to the seascape.

The second photo, taken with faster film, is substantially grainier than the first one. This graininess is particularly noticeable in the spray of the surf. Whether you want this level of graininess in your photos is a matter of personal preference; sometimes grainy photos are pleasing, but sometimes the graininess may not suit the subject or the mood of the image. In this instance, I was using the faster film—and pushed the film (as explained on page 41) to a higher speed—because my main goal that afternoon was to photograph a nearby group of harbor seals. I needed the additional boost in film speed so I could get sharp pictures of seals moving in the late afternoon light.

Quick Tip

Always carry a few rolls of high-speed film to be prepared for low-light or fast-motion opportunities that arise in outdoor photography.

Tide Pools

Technical Specifications:

Setting: Cape Perpetua Scenic Area, Siuslaw National Forest, Oregon, July afternoon

Lens: 28–200mm zoom set at 28mm (top), 28–200mm zoom set at 200mm (center and bottom)

Film: Fujichrome 100

Exposure: $\frac{1}{10}$ second at f/22 (top), $\frac{1}{2}$ second at f/32 (center), $\frac{1}{20}$ second at f/8 with polarizing filter (bottom)

Tide pools are a veritable photographic gold mine. If you ever tire of photographing the big coastal scenics, visit a rocky shore at low tide, move in close and explore the wonders of tide pool life. Specialized plants and animals with remarkable physical adaptations carpet every available square inch of living space in this unforgiving environment that is alternately heated and cooled to extremes, pounded by surf and dried by the sun. These three images illustrate some of the opportunities and challenges of tide pool photography.

The first photo (top) is a wide-angle view of tide pools on a ledge below me. I chose to include the brightly lit surf at the top to give a sense of the scale and context of the pools. This image highlights a nice mix of textures including the rugged rocks, the light-toned barnacles, the soft algae and the sun-splashed waves.

For the second photo (center) I set up my tripod very low next to a tide pool and zoomed to a 200mm focal length for a portrait of the edge of the pool. I was drawn to the diagonal necklace of star-shaped sun reflections in the water in the upper left part of the image. Stopping the lens down to f/32 enhanced this starburst effect, while maximizing the depth of field. The third photo (bottom), more close-up than the second one, iso-lates a single sea anemone. The combination of three factors—a 200mm focal length, an aperture of f/8 and focusing at close range—ensured shallow depth of field. This helped me emphasize the subject by getting the anemone's feelers in focus, while blurring much of the rest of the image. The other key to this image was a polarizing filter, which eliminated reflections on the surface of the water, thus allowing a clear view of the anemone.

Tide levels vary significantly during the course of the lunar cycle. For the best tide pool photo opportunities, check local tide tables to find dates when the lowest low tides will occur. Keep in mind that the living organisms that inhabit tide pools are easily damaged by your feet and tripod. Step as carefully as possible, and strive for minimum impact; always try to leave tide pools in the same condition you found them.

Quick Tip

A tripod that allows you to get down very low, a close-up lens and a polarizing filter are useful equipment for photographing tide pools.

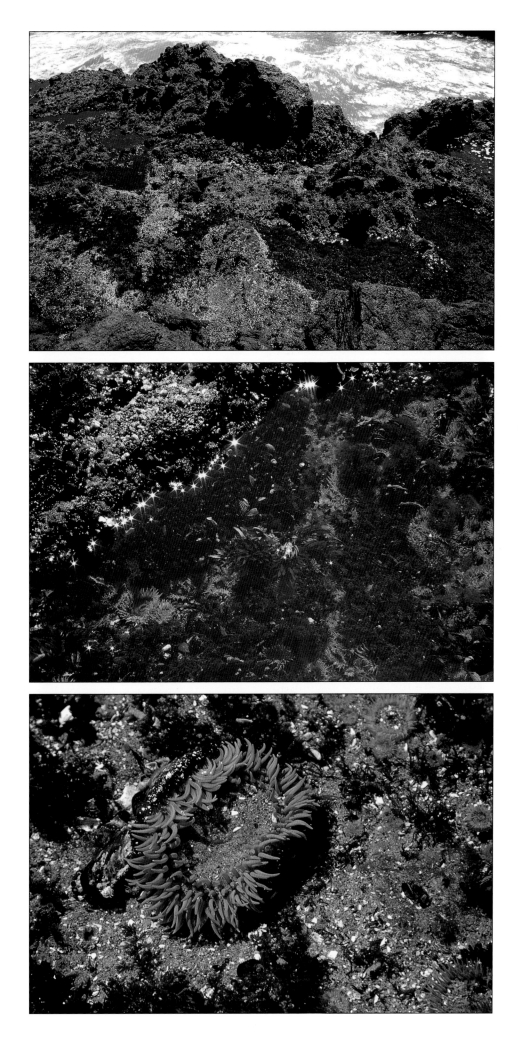

Ripple Marks

Technical Specifications:

SETTING: Popham Beach State Park, Maine, August sunset

LENS: 70–210mm zoom

FILM: Kodachrome 25

In composing photographs, simplicity works. Some landscapes have an inherent simplicity that is easy to photograph well, but other scenes are far more complex and may be very challenging to compose. Lighting typically plays a major role in shaping the visual complexity of a scene. For example, strong side lighting produces prominent shadows and frequently adds to the visual complexity of a scene. On the other hand, either backlighting—which can produce silhouettes—or weak, diffuse lighting may serve to reduce the visual complexity of a landscape.

I took this photo as the sun set at the end of a hazy summer day on the coast of Maine. I was looking northwestward across tidal flats toward the maritime forest. As the sun sank into the haze, its light was very weak, just strong enough to provide a nice off-center focal point to the photograph and an elongated reflection in the wet sand.

If I had framed the image without the series of ripple marks in the foreground, the scene would have appeared flat. You can clearly see this effect by covering the lower half of the photo with your hands. By filling more than a third of the image with the ripple marks, I added significant visual appeal to the scene and also gave the landscape a feeling of depth. The curved but largely vertical lines of the ripple marks lead the viewer's eye up into the scene toward the sun and its reflection. These vertical lines contrast with the soft horizontal lines of the land in the upper half of the image. Nonetheless, the image retains an overall sense of peacefulness and stability . . . as coastal sunsets often do!

Quick Tip

Use telephoto lenses to alter distance relationships by bringing the foreground and background closer together than they appear to the eye.

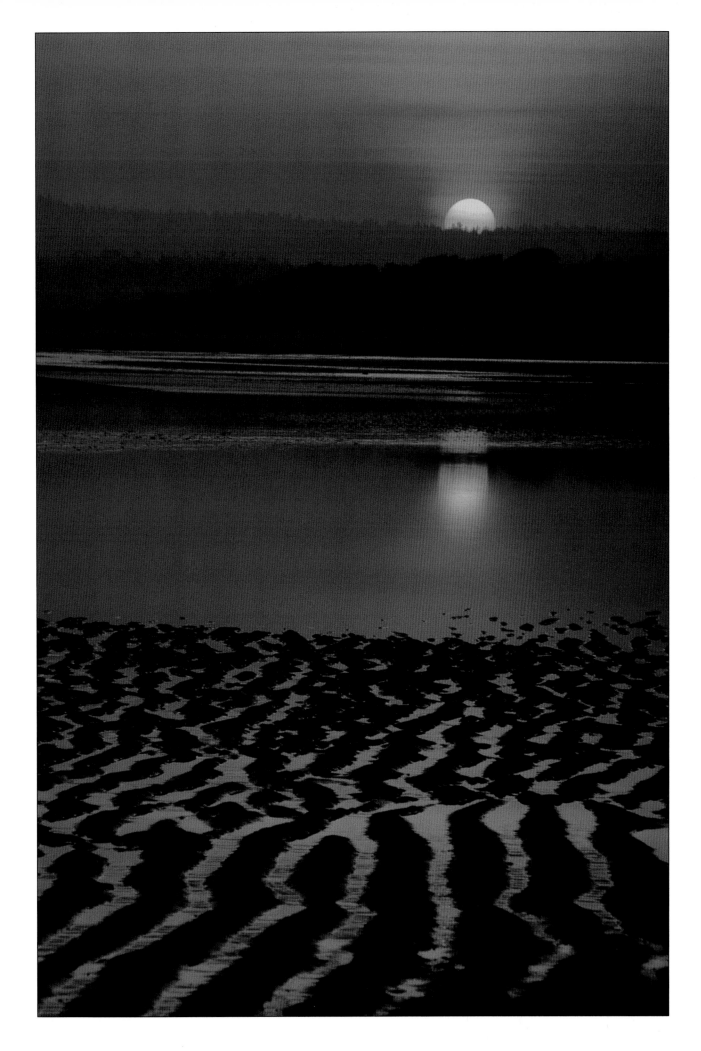

Sea Level

Technical Specifications:

SETTING: Cape Kiwanda State Park, Oregon, June afternoon

LENS: 17mm

FILM: Agfa Scala 200x black & white slide film

EXPOSURE: $\frac{1}{500}$ second at f/6.7

A low camera position combined with an ultrawide-angle lens can produce splendid images of broad, flat beaches. I set my camera and 17mm lens up on the tripod just above sea level for this expansive view of a Pacific beach on a bright and hazy summer afternoon. I metered the full scene as you see it, then intentionally overexposed by $\frac{1}{2}$ stop to partially compensate for the fact that the sunlit beach was much lighter than the medium gray tone for which my light meter is calibrated. Since I only overexposed by $\frac{1}{2}$ stop, and the scene was between one and two stops lighter than a middle tone, the photo is still underexposed compared to the actual scene as I saw it. By deepening the tones and "holding" the detail in the lighter parts of the image, this underexposure added more drama and visual interest to the photo.

Quick Tip

As a final step in composition, make sure your horizon is truly horizontal so that the ocean does not appear to be spilling out of the image.

I chose a fast shutter speed of $\frac{1}{500}$ second in order to freeze all motion of the backwash on the beach. Given the inherently large depth of field of a 17mm lens, the aperture of f/6.7 is adequate to ensure a sharp image from front to back. Notice how comparatively small features add up to so much in this image; for instance, the lines of foam in the left half of the image, the reflection of the sun on the wet beach in the lower right, the dark stones in the foreground, and the headland and small island at the upper left.

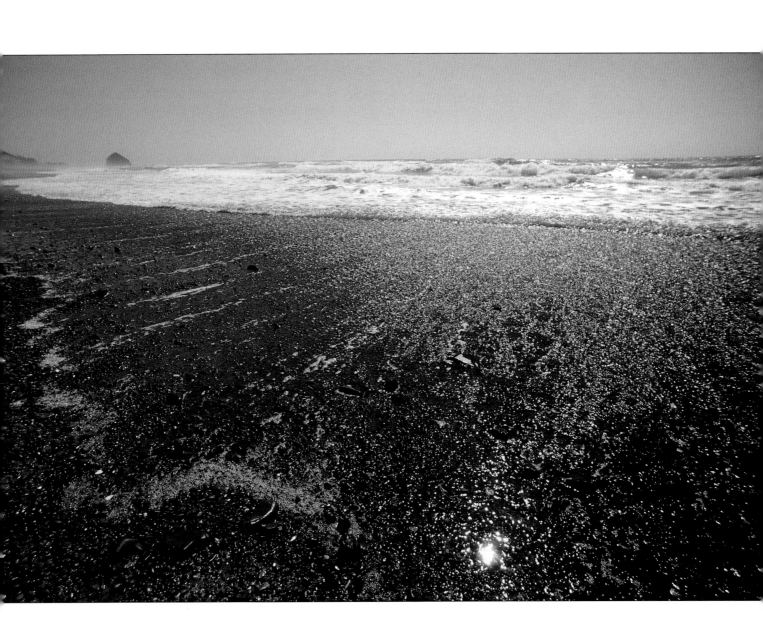

Horizon Placement

Technical Specifications:

SETTING: Oceanside, Oregon, June morning
LENS: 28–200mm zoom set at 28mm
FILM: Kodak Ektachrome 100
EXPOSURE: $\frac{1}{125}$ second at f/11

Making simple choices well pays big dividends photographically. The same scene, same viewpoint, same lens and same exposure can produce strikingly different photographs, depending on how you compose the image. Two fundamental variables—the placement of the horizon and the choice of either vertical or horizontal format—make major differences in the appearance of a photograph.

In this case, I was initially interested in a wide-angle view of the rocky coastline contrasted against the immensity of the sky. I composed the seascape horizontally and, to emphasize the sky, I placed the horizon in the bottom fourth of the photo. The resulting horizontal photo shows only a small slice of ocean and beach. The visual mass of the dark, rocky cliffs on the right balances the lightness of the cloudy sky.

After photographing the horizontal composition, I composed a vertical image at the same 28mm focal length. This time I placed the horizon one-third of the way down from the top of the image, and thus shifted the visual emphasis from the sky to the land. This high horizon placement left ample room to include a large rocky outcrop in the right foreground to anchor the image. Notice how this strong foreground gives the vertical photo a much deeper look than the horizontal photo.

This particular vertical composition would have been impossible standing right at sea level

on the beach. For both compositions, I stood on the highest part of the rocky outcrop that is visible in the vertical composition, giving me a bit of an aerial perspective as I looked northward along the coastline. Getting even a few feet above the level of the beach frequently improves your potential to produce interesting photographs of coastal landscapes.

Quick Tip

When you find an attractive seascape, check for potential horizontal and vertical compositions with a variety of horizon placements.

Really Low Light

Technical Specifications:

SETTING: Harris Beach State Park, Oregon, March night and dawn

LENS: 50mm (top), 28–70mm zoom (bottom)

FILM: Kodachrome 25

EXPOSURE: 9 minutes at f/1.7 (top), 4 seconds at f/8 (bottom)

There is no need to stop photographing the natural world just because it gets dark! The land, the water and the earth's wondrous beauty are still there at night. Wherever you are, there is always some light. If you are willing to keep your camera's shutter open long enough, you can produce a well exposed photograph by making use of the ambient light.

The first image (top) is a seascape north of the Oregon-California border that I photographed late at night under a full moon. I was using glacially slow ISO 25 slide film because of its exquisite sharpness and fine detail. Thus I had to keep the shutter open for nine minutes, even with a very fast 50mm f/1.7 lens set wide open. I kept the shutter open—and the camera steady—for such a long period by mounting the camera on a tripod, attaching a cable release to the camera, pushing the plunger on the cable release and then locking the cable release in that position. Nine minutes later, after adding more wood to the campfire and putting on a heavier sweater, I unlocked the cable release to end the exposure.

Determining the proper exposure for nighttime photography is partly calculation, partly estimation and partly a matter of experience. Film suffers significant reciprocity failure when you take long exposures of many seconds or minutes in length. In a nutshell, this means the film emulsion no longer responds to longer exposures in the same regular, predictable manner that it does with exposures measured in fractions of a second. Many photographic reference books list suggested exposures for various nighttime photo situations. The key is to set your lens aperture wide open and bracket your exposures, using longer and longer shutter speeds by doubling and quadrupling your estimated exposure times.

Quick Tip

For the best results with extended time exposures at night, take numerous exposures of significantly different lengths.

When you photograph landscapes at night, try to err on the side of overexposure, because underexposure of night landscapes is a much more common occurrence than overexposure. Frankly, it is easy to underexpose nighttime photos, but comparatively difficult to overexpose them!

For comparison purposes, I took the second photo (bottom) early the following morning under the more abundant, but still weak, light as the sky turned pink at dawn. The light was low enough that I needed a substantial exposure of four seconds at f/8. A short telephoto focal length gave me a tighter framing of the seascape at dawn; notice the additional sand and rocks exposed by the ebbing tide.

Wide Angle and Telephoto

Technical Specifications:

SETTING: Ecola State Park, Oregon, September midday

LENS: 28–200mm zoom set at 35mm (top), 75–300mm zoom set at 300mm (bottom)

FILM: Fujichrome 100

EXPOSURE: $\frac{1}{90}$ second at f/11 (top), $\frac{1}{180}$ second at f/11 (bottom)

Your photographic compositions can be as varied as your imagination, your lenses and the variety of landscapes that you photograph. While wide-angle lenses capture the big picture, telephoto lenses are great for magnifying and juxtaposing distant landscape features.

I took these two photos on a beautiful September day in Oregon's photogenic Ecola State Park. The first image (top), made at a 35mm focal length, is a classic wide-angle scenic of the Pacific Northwest coast with its stunning topography, sea stacks and massive rocky headlands separated by crescent-shaped beaches. The gentle curve of the shoreline, extending from the bottom of the image to the top right corner, is a key element of this composition. Notice how the breakers parallel the curve of the shoreline, thus accentuating the visual prominence of the shore.

The second photo (bottom) shows the "reach" of a zoom lens set at a focal length of 300mm, providing more than eight times the magnification of the 35mm focal length used for the first image. This size comparison is illustrated by looking at Haystack Rock, the dark, rocky island that dominates the upper left part of the second photo, then looking at the same feature in the far upper right corner of the first photo.

The second image also benefits from the nice texture created by sunlight sparkling on the wind-rippled ocean surface, and from the gauzy fog hanging along the shore in the background. I chose to overexpose this bright midday scene by one-half stop compared to the metered exposure; this lightened the image compared to the metered exposure. If I had used greater overexposure, the highlights in the water would have lost detail and been washed out.

Quick Tip

Within every wide-angle seascape, look for several good telephoto compositions.

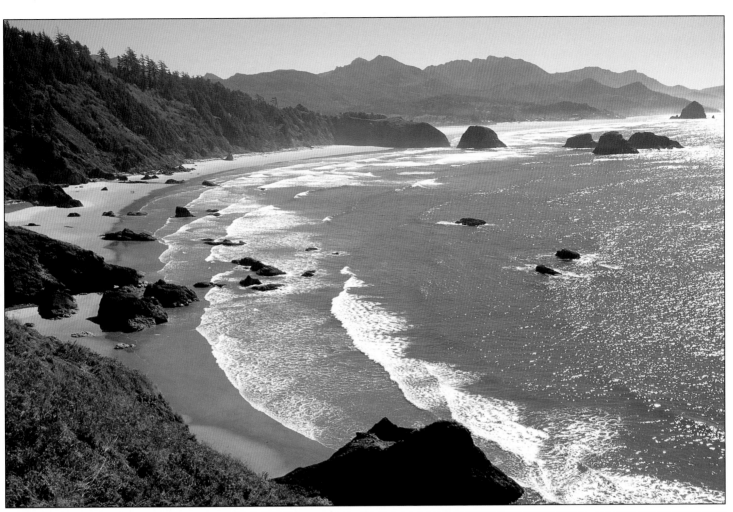

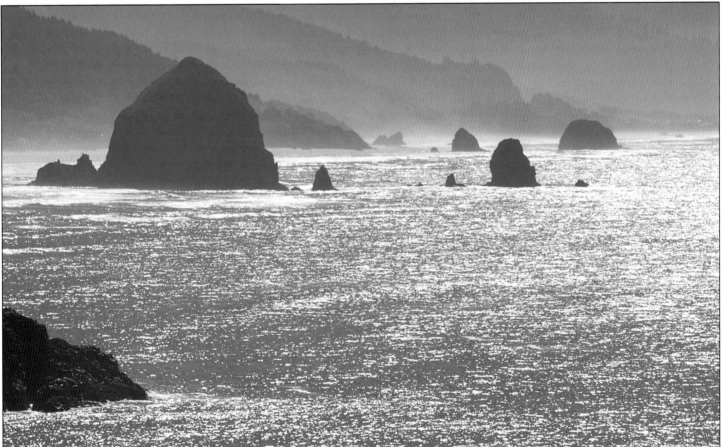

Natural Frame

Technical Specifications:

SETTING: Three Arch Rocks National Wildlife Refuge, Oceanside, Oregon, June morning

LENS: 17mm

FILM: Ektachrome 100

EXPOSURE: ¹⁄₁₂₅ second at f/11

When photographing on rocky coastlines, I try to take full advantage of the coastal landforms in my photographic compositions. For this image I set up my tripod inside the mouth of a shallow cave in a cliff on the Oregon coast. By using an extremely wide-angle 17mm lens, I had a broad enough field of view to frame three sides of the photo with the dark basalt of the cave. I took my exposure meter reading from the entire scene just as you see it, knowing that the cave walls would appear largely in silhouette against the much brighter sky and sand.

Notice how the boundary between wet and dry sand forms a diagonal line from the lower right corner to a point near the center of the picture, leading the viewer's eye into the image. The photo is also enhanced by feathery white clouds, which give the sky more definition, and by the pebbles scattered on the surface of the beach.

One of the advantages of wide-angle lenses is the great depth of field they provide. With the aperture set at f/11 and the lens focused near the middle of the scene, the image appears sharply focused all the way from the immediate foreground to the horizon.

Quick Tip

Seek out coastal landscape elements that can be used to provide natural frames for your compositions.

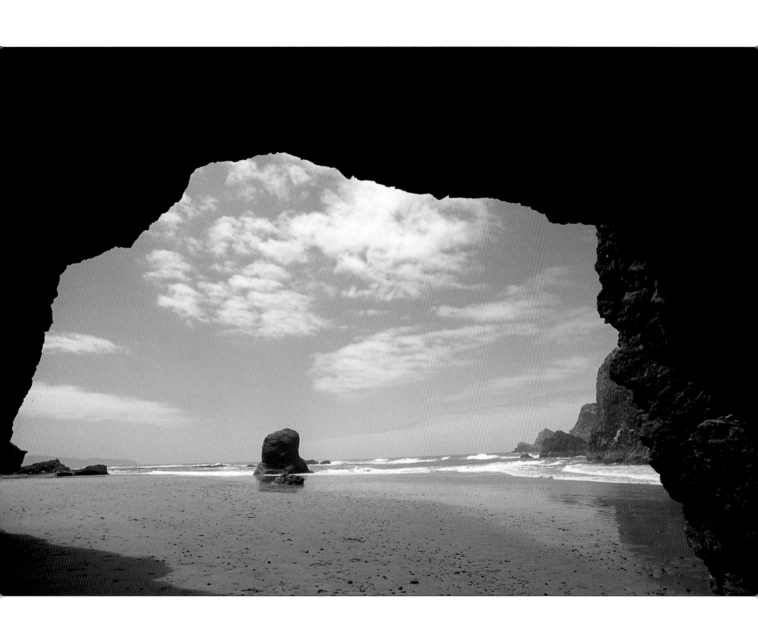

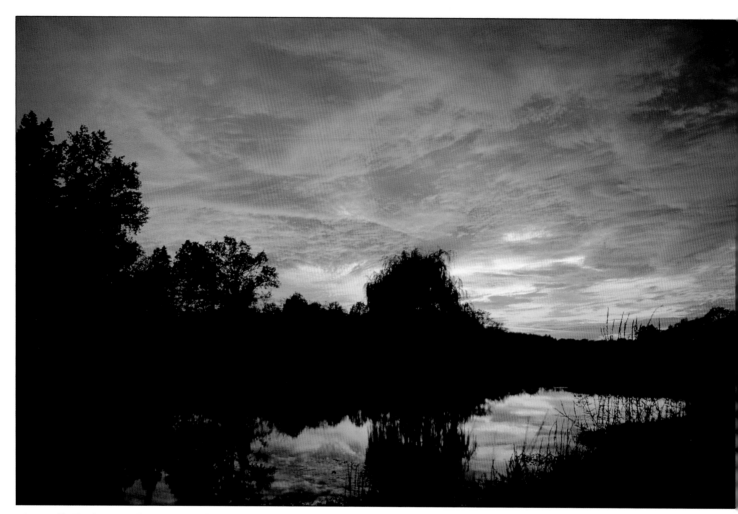

A small Hudson Valley pond reflects the brilliant evening sky. The land and trees appear in silhouette, since I chose to set my exposure based on a light meter reading of the entire scene as you see it. (28–70mm zoom lens; Fujichrome 100 film)

Portfolio

SELECTED

IMAGES

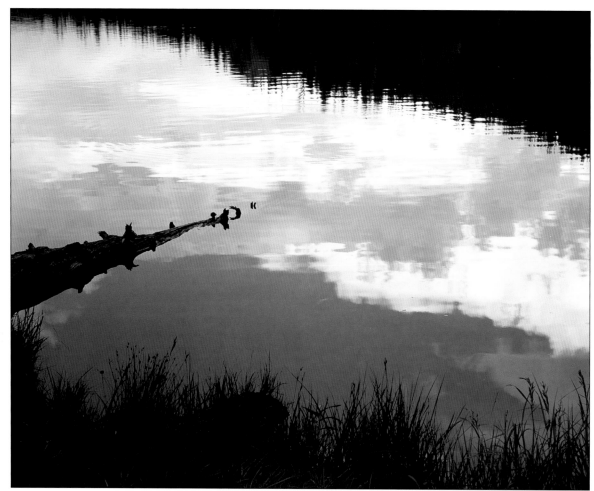

Above: A tiny Alpine lake in Rocky Mountain National Park, Colorado, reflects the blue sky and white clouds. I composed this image with simplicity in mind. I included the grassy shore in the foreground to help orient the viewer. (Medium-format camera with 135mm lens; Fujichrome 100 film)

Right: Forty-five minutes after a frigid January sunset, I photographed this spectacular orange sky reflected in the marshes of Maryland's Blackwater National Wildlife Refuge. My vantage point was an observation tower, affording me this aerial view of the flat wetlands. (70–210mm zoom lens; Kodachrome 25 film)

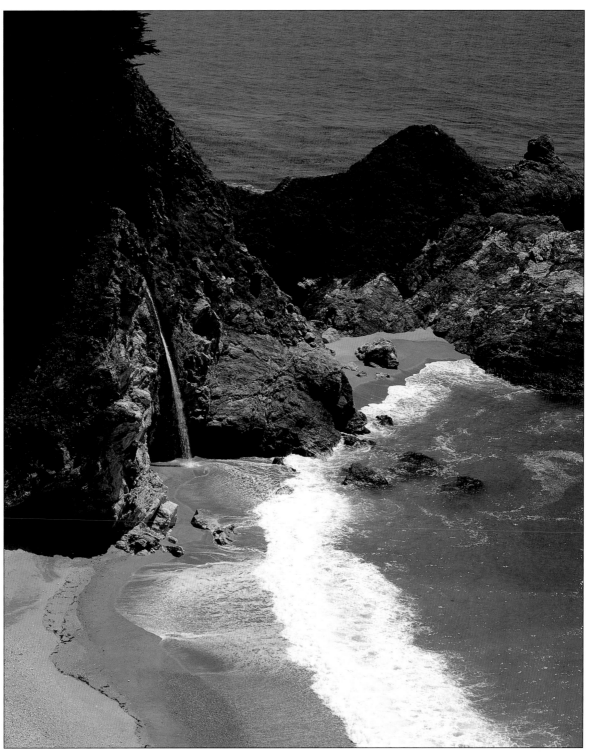

For scenic splendor, a waterfall cascading onto the beach at the edge of the surf along California's Big Sur coastline is about as good as it gets! To compose this image, I worked on the visual balance between the tones and textures of rock, sand, surf and the blue water at the top. (Medium-format camera with 135mm lens; Fujichrome Velvia film)

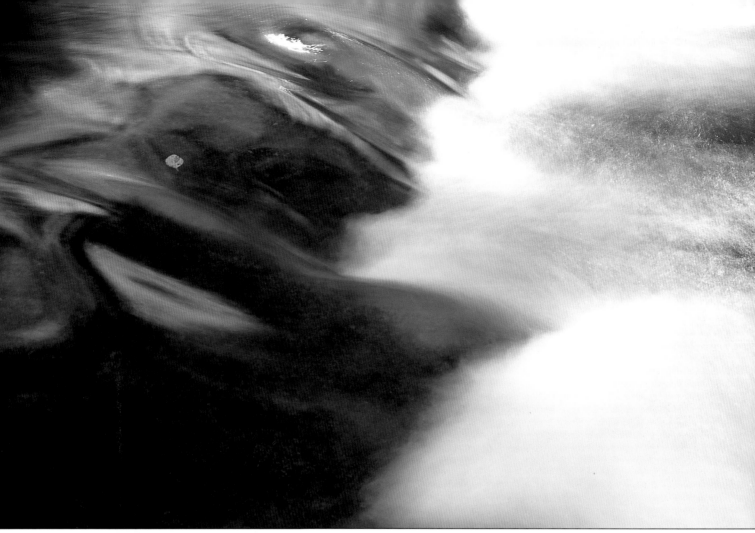

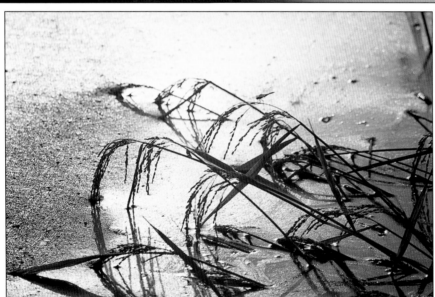

Above (large photo): *This image of Oregon's Drift Creek Wilderness contrasts the creek surface on the left with the turbulent white water on the right. A single yellow leaf is stationary on the stream bottom at the upper left; everything else is in motion. (28–200mm zoom lens set at 50mm; Fujichrome 100 film; 1.5 seconds at f/27)*

Above (small photo): *This early morning still life of a rice paddy in Bangladesh features strong back-lighting. High contrast, diagonal lines, a simple background and a single dragonfly stand out in this composition. (75–300mm zoom lens; Fujichrome 100)*

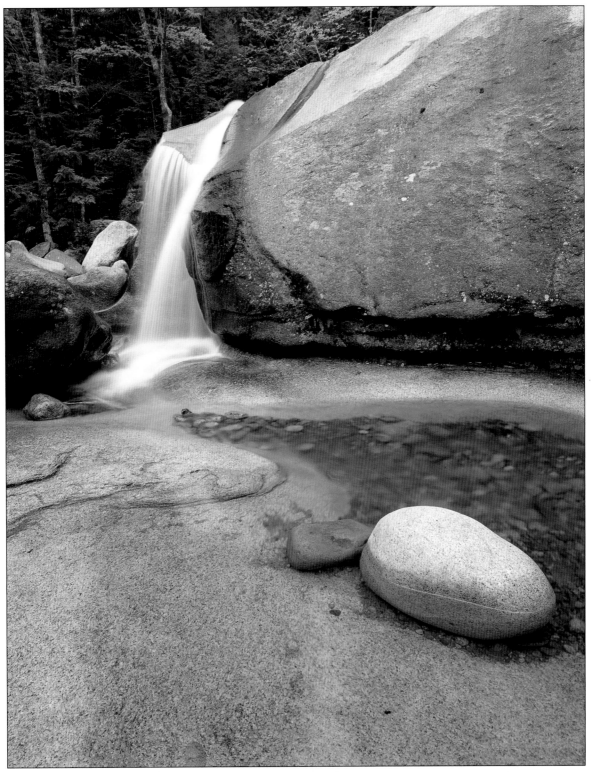

This is an unusual composition of a waterfall at Diana's Baths in White Mountain National Forest, New Hampshire. Rather than putting the waterfall up front as the main focal point of the image, I placed it in the background and let the boulders and bedrock take center stage in the photograph. (Medium-format camera with 45mm lens; Fujichrome Velvia film)

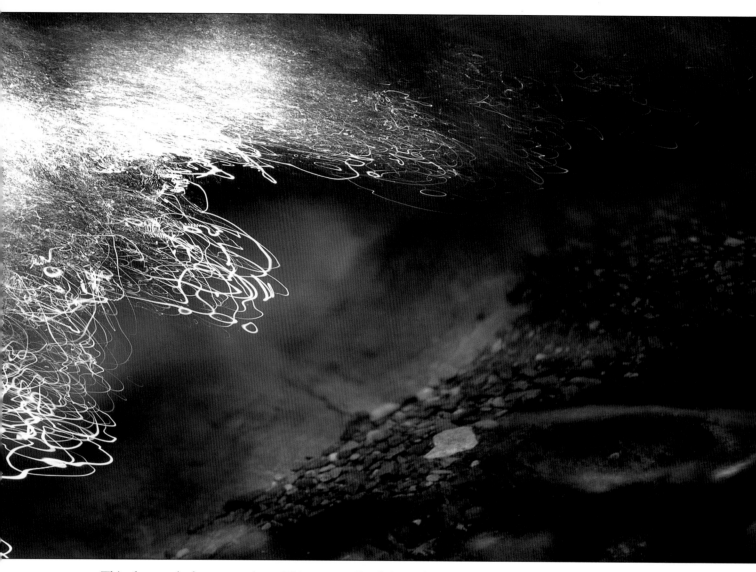

This close-up look at a portion of Dingmans Creek in Delaware Water Gap National Recreation Area, Pennsylvania, contrasts the highlights of sunlight sparkling on the water surface with the dark, pebbly stream bottom. (75–300mm zoom lens set at 100mm; Fujichrome 100; exposure: 8 seconds at f/22)

Below (small photo): *Wildlife and running water often work well together in photos. I photographed this mule deer fording the Big Thompson River after the first snow of autumn in Rocky Mountain National Park, Colorado. (180mm lens; Fujichrome 100 film)*

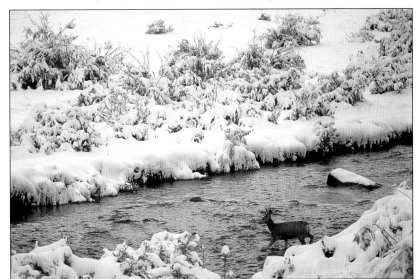

Below (large photo): *By closely observing sunlit waterfalls, you will often find bands of color that look like partial rainbows, where sunlight is refracted by the drops of spray. In this image, Latourell Falls in the Columbia Gorge National Scenic Area is framed by maple trees and columnar basalt. (28–200mm zoom lens set at 200mm; Fujichrome 100; 1/90 second at f/6.5)*

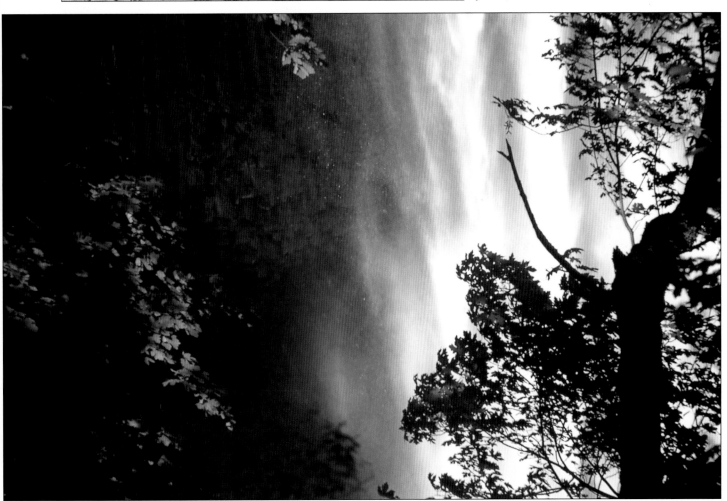

Glossary

Aperture: The diameter of the lens opening through which light passes to reach the film. Apertures are commonly expressed as f-stops.

Bracketing: The technique of taking two or more exposures of the same scene with slightly different exposure settings; this is usually done by taking an exposure at the metered exposure setting, then taking additional exposures at other settings varying from one another by half or full stops. Bracketing is often used in difficult or unusual exposure situations.

Composition: In a photograph, the arrangement in the frame of the artistic elements such as lines, shapes, forms, colors, tones, patterns, textures, contrast, lighting, balance and perspective.

Depth of field: The range of distances from near to far that appear in acceptably sharp focus in a photograph. Depth of field depends on the focal length of the lens, the lens aperture (f-stop) and the distance at which the lens is focused. The shorter the focal length, the smaller the aperture, and the longer the focusing distance, the greater the depth of field will be.

Depth-of-field preview: A feature on some cameras that lets the photographer actually see the front-to-back zone of sharpness that will appear in a photograph.

Exposure: The amount of light that reaches the film. Exposure is determined by the duration and intensity of light striking the film; these two variables are controlled by the shutter speed and aperture respectively.

Exposure meter: A light-measuring device built into your camera that determines how much light is reflected from the subject and thus how to expose the image. Also known as

light meter or simply *meter*. As a verb, *metering* refers to pointing your camera toward a subject to measure how much light is reflected from it.

Film speed: A measure of film's sensitivity to light. Film speed is rated on a standard scale known as ISO; for example, an ISO 200 film is twice as light sensitive as an ISO 100 film.

Filter: A supplementary lens attachment that is mounted or screwed onto the front of a lens or mounted on a bracket attached to the lens to enhance photographic images.

Focal length: The distance from the optical center of a lens to the film, measured in millimeters; this is the standard way of identifying lenses.

f-stop: The standard way of expressing the lens aperture (the diameter of the lens opening). Lenses have a standard series of apertures including f/2.8, f/4, f/5.6, f/8, f/11, f/16, and f/22, where f represents the focal length of the lens. Thus, f/2.8 is a comparatively large lens opening; f/22 is a comparatively small lens opening.

Lens speed: The largest aperture of a particular lens.

Medium format: A film format considerably larger than 35mm film. Medium-format cameras use 120 or 220 roll film and produce negatives or slides with dimensions such as 6x4.5cm, 6x6cm, 6x7cm and 6x9cm.

Overexposure: A photo or a portion of a photo that is too light ("washed out") because the film was exposed to too much light.

Polarizing filter: A filter that reduces reflections from shiny surfaces, enhances color saturation and deepens blue skies.

Rule of thirds: A guideline for photo composition that suggests visualizing your viewfinder as divided into thirds, then placing

the main subject(s) in your composition near the intersections of these "thirds" lines.

Shutter speed: The amount of time that the camera's shutter is open during an exposure to allow light to reach the film. Cameras have a standard series of shutter speeds measured in fractions of a second, including $\frac{1}{1000}$ second, $\frac{1}{500}$ second, $\frac{1}{250}$ second, $\frac{1}{125}$ second, $\frac{1}{60}$ second, $\frac{1}{30}$ second and so on.

Slide film: Film that produces positive transparencies, commonly known as slides, rather than negatives.

SLR camera: A single lens reflex (SLR) camera has a viewfinder that allows you to look through the lens. SLRs use interchangeable lenses.

Spot meter: A type of exposure meter, built into some SLRs and point & shoot cameras, that evaluates the reflected lighting of a small area—a "spot"—in the center of the image as seen through the viewfinder.

Stop: The increments between each of the standard shutter speeds and between each of the standard apertures (f-stops). Changing either the shutter speed or the aperture by one stop will either double or cut in half the amount of light that will reach the film during an exposure.

Telephoto lens: A lens with a focal length significantly longer than 50mm.

35mm film: The most common format for SLR cameras and film; each frame is approximately 35mm long.

Underexposure: A photo or a portion of a photo that is too dark because the film was not exposed to enough light.

Wide-angle lens: A lens with a focal length significantly shorter than 50mm; such a lens takes in a broad view.

Zoom lens: A lens that can be adjusted to a range of different focal lengths.

Appendix

● **Great Locations
for Waterfall Photography**

While Yosemite and Yellowstone national parks are world-renowned for their scenic wonders and spectacular waterfalls, there are many other American sites with excellent waterfall photo opportunities. Here are three of my favorites, each of which can provide long days of photographic adventure:

Columbia Gorge National Scenic Area, Oregon-Washington. By any account—whether Lewis and Clark's or that of contem-

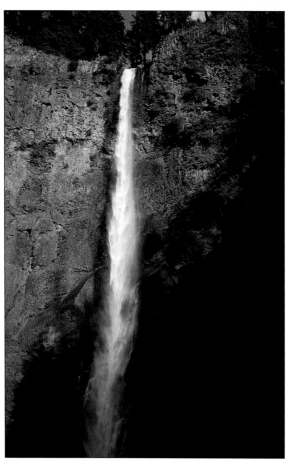

Towering Multnomah Falls, Oregon, is a magnet for waterfall photographers in the Columbia Gorge. Late afternoon light on the falls is often superb in summer. (35mm lens; Ektachrome 100 film)

porary tourists—the mighty Columbia River's path through the Cascade Mountains is a waterfall-lover's mecca. The eighty-mile-long Columbia Gorge has an abundance of eye-catching waterfalls that are easily accessible from I-84 on the Oregon side of the river. The highlight for most visitors is Multnomah Falls, which drops 620 feet. Nearby Wahkeena Falls and Latourell Falls are also more than 240 feet in height. Late spring and early summer are ideal for both waterfall-viewing and wildflower photography in the Columbia Gorge.

For information, visit their website (www. fs.fed.us/r6/columbia) or call (541)386-2333.

If you visit the Columbia Gorge, a rewarding side trip for additional waterfall photography is less than a two-hour drive to the south at Oregon's Silver Falls State Park, which features ten photogenic waterfalls—five of which exceed 100' in height—on the trail through Silver Falls Canyon.

For information, visit their website (www.prd.state. or.us) or call (800)551-6949.

Nantahala National Forest, North Carolina. This mountainous Southern Appalachian forest covers more than a half-million acres. Nantahala National Forest has elevations ranging from 1,200 to 5,800 feet and as much as 75" of rainfall a year, which add up to great waterfalls. Some of the most photogenic falls are along U.S. 64 between the towns of Franklin and Highlands on the Cullasaja River. Two unusual roadside attractions on this route are Dry Falls, which you can walk under, and Bridal Veil Falls, which you can drive under; in both cases you can compose interesting photos by looking out at the forest from beneath the falls. The crown jewel is magnificent

Whitewater Falls, just north of the South Carolina border. With a total drop of 411 feet, Whitewater Falls is the highest waterfall east of the Rockies. Spring and early summer are wonderfully photogenic here, especially if you time your visit to catch the rhododendron and mountain laurel in bloom.

For information about Nantahala National Forest, visit their website (www.cs.unca.edu/nfsnc) or call (828)257-4202.

Ricketts Glen State Park, Pennsylvania. This 13,000-acre state park in northeastern Pennsylvania is a gem of a waterfall site. The forested park includes twenty-two named waterfalls, ranging in height from twelve to ninety-four feet, in the course of a four-mile loop hike along the two steep branches of Kitchen Creek.

The photographic highlights include

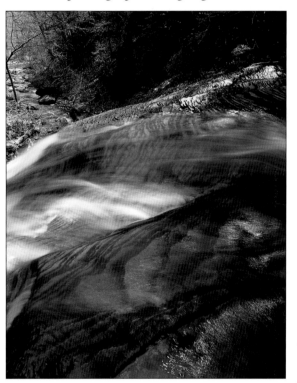

A wide-angle view of the top of Huron Falls in Ricketts Glen State Park, Pennsylvania, contrasts the layer cake of rock shelves that supports the falls and the stream below the falls in the background. (Medium-format camera with 45mm lens; Ektachrome 100 film)

Oneonta, Huron, Mohawk and Ganoga falls. Go early in the morning and spend a full day photographing from vantage points above, beside and below each of the falls. Autumn, particularly early to mid-October, is a wonderful time to visit Ricketts Glen and photograph the falls against a backdrop of colorful autumn foliage provided by beech, birch, maple and

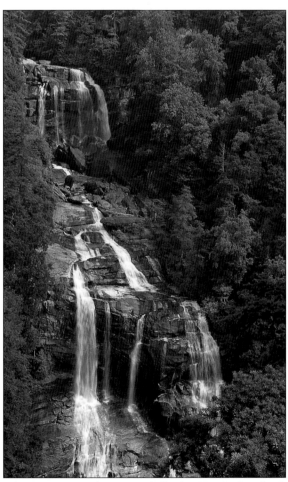

This image of Whitewater Falls, in North Carolina's Nantahala National Forest, illustrates the appropriateness of the name of this Eastern giant among waterfalls. (28–200mm zoom lens set at 55mm; Fujichrome 100 film; exposure: ⅒ second at f/27)

oak trees.

For information, visit their website (www.dcnr.state.pa.us) or call (570)477-5675.

● **Camera Care for Water Photography**
Modern photographic equipment is capable of withstanding the hard knocks and weather extremes of outdoor photography. The following tips will help ensure that your equipment endures for many years of field use as you photograph water both inland and at the coast:

1. You can photograph in rain or snow, but keep your camera covered except when you are actually taking pictures. Outdoor photographers use a variety of commonsense accessories to keep their cameras dry, for example, large plastic bags, umbrellas, plastic ponchos and rain hats. When you return from rainy or snowy field sessions, promptly dry your camera, lenses and tripods with a soft towel, then allow them to air out in a warm, dry location.

2. When you photograph in locations where your camera will likely get sprayed with water—such as below waterfalls, around white water rapids or near surf—use an ultraviolet (UV), skylight or haze filter to protect your lens. In these spray situations you may have to frequently wipe moisture off the front of your lens; it is far better to be repeatedly wiping off an inexpensive filter than an expensive lens. If you are planning to photograph in a situation where a really wet camera is almost a certainty, for instance, a white-water rafting trip, you may want to use an inexpensive waterproof point-and-shoot camera or else purchase a protective waterproof housing for your camera.

3. On foggy or rainy days, your lens may continually fog up to the point that photography seems impossible. Again, the best solution may be to keep an ultraviolet (UV), skylight or haze filter on your lens. When you are ready to focus and take an exposure, simply remove the fogged-up filter, take your photo, then quickly put the filter back on. Frequently, only the external surfaces will fog up, so your filter-protected lens will stay clear.

4. If you accidentally drop your camera in a lake or river, immediately dry out the camera and lens as much as possible, then rapidly deliver it to a good camera repair facility. Do not microwave your camera! Cameras that have been immersed in fresh water can sometimes be saved; in fact, I still use a camera and zoom lens that fell in a Pennsylvania creek eight years ago.

5. The sand and salty air that are an inherent part of photogenic coastal locations are also potentially hazardous to camera equipment. Always avoid getting sand or saltwater on your camera. Tiny sand grains can jam moving parts, and salt spray can cause internal components to rust over time. Do not leave your camera uncovered on a beach towel! When you return from coastal photo outings, carefully wipe off your camera, lenses and tripod with a soft, barely damp cloth, then thoroughly dry your equipment.

6. Following coastal photo sessions, you may also need to wipe a salty film off the front of your lenses and filters. Prior to cleaning, use a very soft brush to sweep away any sand or grit that is on the lens. Then to get the film off the lens, use only lens-cleaning cloths and solutions that are made specifically for photographic lenses. Clean your lenses and filters no more than necessary, since they have special coatings that are critical to their optical performance.

● **Equipment Notes**
The vast majority of the 35mm photos in this book were made with Canon and Leica SLR cameras and Canon, Leitz, Tamron and Sigma

lenses. The medium-format images were produced with a Pentax 67 camera with a TTL (through-the-lens) pentaprism viewfinder and SMC Pentax lenses. I use a Bogen 3221S tripod with spiked feet, a Slik AF Pistol-Grip Head and Tiffen filters.

I use Fujichrome and Ektachrome color slide films with speeds of ISO 100 or less for more than 95% of my photography. My favorite all-purpose film is Fujichrome Provia 100F. The handful of photos in this book that I produced with higher-speed color slide films or with Agfa Scala 200x black & white slide film are identified accordingly in the photo descriptions or captions.

Index

Other Books from
Amherst Media™

Infrared Landscape Photography

Todd Damiano

Landscapes shot with infrared can become breathtaking and ghostly images. The author analyzes over fifty of his most compelling photographs to teach you the techniques you need to capture landscapes with infrared. $29.95 list, 8½x11, 120p, 60 b&w photos, index, order no. 1636.

Essential Skills for Nature Photography

Cub Kahn

Learn all the skills you need to capture landscapes, animals, flowers and the entire natural world on film. Includes: selecting equipment, choosing locations, evaluating compositions, filters, and much more! $29.95 list, 8½x11, 128p, .60 photos, order no. 1652.

Black & White Landscape Photography

John Collett and David Collett

Master the art of b&w landscape photography. Includes: selecting equipment (cameras, lenses, filters, etc.) for landscape photography, shooting in the field, using the Zone System, and printing your images for professional results. $29.95 list, 8½x11, 128p, 80 b&w photos, order no. 1654.

Outdoor and Survival Skills for Nature Photographers

Ralph LaPlant and Amy Sharpe

An essential guide for photographing outdoors. Learn all the skills you need to have a safe and productive shoot – from selecting equipment, to finding subjects, to dealing with injuries. $17.95 list, 8½x11, 80p, order no. 1678.

Professional Secrets of Nature Photography

Judy Holmes

Improve your nature photography with this must-have book. Covers every aspect of making top-quality images, from selecting the right equipment, to choosing the best subjects, to shooting techniques for professional results every time. $29.95 list, 8½x11, 120p, 100 color photos, order no. 1682.

Art and Science of Butterfly Photography

William Folsom

Understand and predict butterfly behavior (including feeding, mating and migrational patterns), when to photograph them and even how to lure butterflies. Then discover the photographic techniques for capturing breathtaking images of these colorful creatures. $29.95 list, 8½x11, 120p, 100 photos, order no. 1680.

Composition Techniques from a Master Photographer

Ernst Wildi

In photography, composition can make the difference between dull and dazzling. Master photographer Ernst Wildi teaches you his techniques for evaluating subjects and composing powerful images in this beautiful full color book. $29.95 list, 8½x11, 128p, 100+ full color photos order no. 1685.